PRAISE FOR
Joe Andoe and *Jubilee City*

"Charming. . . . [Andoe's] wide-eyed sense of wonder and keen observations make the everyday strange and fresh."
—*Publishers Weekly*

"Not every painter of lonely landscapes and stark, haunting creatures has a readable story to tell. But Mr. Andoe makes this book a natural offshoot of his art, combining cool understatement with brass-tacks candor." —*New York Times*

"A raw, laconic kind of confession . . . filled with the kind of sentences that demand a reader's attention." —*USA Today*

"[Andoe] has a gift for ruthless analysis, and among the disjointed microchapters of his life story, there are exacting self-revelations every few pages. . . . Now that he's sobered up, he's able to survey the car wreck of his early life and turn it into a kind of art." —*New York Times Book Review*

"Joe Andoe talks the way he paints in simple, direct phrases. He's no horseman. He's always preferred fast cars and motorcycles." —NPR's *All Things Considered*

"A coming-of-age centered on cars, fields, and how much alcohol you could scavenge on a Saturday night merges into car crashes, construction jobs, unpredictable friends, college, painting, a heat-of-the-moment marriage proposal followed by a resigned acceptance, children, a move to New York, drugs, violence, money made and lost, fame and international recognition. . . . [Andoe] deserves our attention and appreciation."
—Associated Press

JUBILEE CITY

JUBILEE CITY

A Memoir at Full Speed

JOE ANDOE

HARPER PERENNIAL

NEW YORK • LONDON • TORONTO • SYDNEY • NEW DELHI • AUCKLAND

HARPER ● PERENNIAL

Page 211 constitutes a continuation of this copyright page.

A hardcover edition of this book was published in 2007 by William Morrow, an imprint of HarperCollins Publishers.

P.S.™ is a trademark of HarperCollins Publishers.

FIRST HARPER PERENNIAL EDITION PUBLISHED 2008.

Designed by Betty Lew

All art copyright © by Joe Andoe

Library of Congress Cataloging-in-Publication Data is available upon request.

ISBN 978-0-06-124032-4

08 09 10 11 12 DT/RRD 10 9 8 7 6 5 4 3 2 1

If anyone has a problem with this book,
talk to Debbie Stier because it was her idea

JUBILEE CITY

FENCE

I was in the backyard of our new rented house in Tulsa, and on the other side of the fence that separated our yard from the people behind was a bunch of little kids, a babysitter's bunch.

I was four or five and talking to a kid, about like me, through the gray diamond-shaped links.

Can you come over and play? he goes.

I don't know, I said. I'll go ask my mama.

So I did and she said, You know they look close but they're really far away.

I remember wondering, Does the fence act like a telescope or a magnifying thing?

Around the same time my twenty-five-year-old mother took me to the grocery store in a hurry. We parked and it was crowded. She put me up on top of a fiberglass horse and dropped a nickel in the box and the horse ground back and forth for a few minutes. Then it stopped. Disoriented, I thought she forgot me and I ran out into the sun and the parking lot looking for her.

Then a friendly old man came out of nowhere, took my

hand, and walked me away and smiled as I said, No, she's back there.

He said that we would find her this way.

Looking back toward the store I told the man my address and phone number like my mother taught me to if I ever got lost. We turned the corner and went into a liquor store where he was familiar with the woman who worked there.

Right away she picked up the phone book as I told her my address and phone number.

I was thinking, Why is she looking in the phone book? Then she made a call. Then the old man and I sat on the curb in the shade in front of the liquor store and we talked to the lady as we waited for something.

Very soon a black-and-white police car pulled up. It had a big gold star on the door. I got in the front seat.

I was too small to see over the dash but I could see the curly black rubber cord (like for a telephone, but thicker) going from the radio to the hand microphone he was talking into, and I saw his big silver pistol in a black holster. I tried to tell him my address but he said he already knew. How does he know? I wondered.

Then we pulled up to my grandparents' house.

Out front stood my smiling grandma and my not happy red-eyed mother who I was so glad to see. I jumped out of the police car and ran to her but she didn't smile or hug or anything; she said, Get in the house.

And yes, I wondered why she wasn't glad to see me.

BABY NEEDS SHOES

I was dropped or suffocated or abused or deprived of something, all at the hands of her evil sadistic doctor.

This was what I was told any time I messed up or got poor grades, and I did mess up a lot and I was usually the last to know.

In 1955, when this all started, my mother, Lois, was a nineteen-year-old cutie with red painted toenails and jet black hair and alabaster skin, a gum-popping bank teller who was voted "Best Figure" by the other tellers.

That was before she got pregnant with me while on her honeymoon in San Diego, shouting distance from the naval base where Dad was stationed before he took off for Japan for almost two years.

I looked like I'd been in a fight by the time she saw me hours after my noon delivery, she said.

They had knocked her out because I was so big—almost ten pounds—and she was only five foot three.

So she never trusted that I was okay.

The high point of my birthday, besides being born, was that my first visitor was a famous Indian artist named Acee Blue Eagle, who was a traditionalist and a writer and a performer. He had toured Europe before World War II and performed for Queen Elizabeth when she was a child, and Mussolini, and Hitler, who might have got the idea for his swastika from a symbol of friendship (turned the other way) that was in Acee's exhibit.

At these performances Acee wore full headdress, buck-skins, and moccasins, and played Indian flutes and tom-toms. He would dance and sing Indian songs and tell stories and show his paintings and medicine.

Then there's Walt Disney, who wasn't there, but we did share the same birthday. Walt took Bambi from Acee. I was told that, years earlier, on a trip to New Mexico, he saw Acee's deer paintings that looked like Bambi.

Acee was a friend of the family and worked at home not far away. He saw me before anybody else did, and maybe put some kind of Indian spell or medicine on me, because he was that kind of guy. And I could draw pretty well early on, and I drew a lot of Indians.

Mom's best friend Jane had a girl a few months before I came along and like all baby girls she looked more advanced than me.

I didn't seem to be as engaged as Jane's baby, plus I was so big—all of this was part of my mother's reason for thinking that I was defective.

They say I was a good baby, hardly fussed; I would lie there and entertain myself. And this worked for my mom because she wasn't cuddly anyway.

So here we have this twenty-year-old mother with her groom on the other side of the world and what she thought was a big slug of a baby.

She lived at her mother's, who had remarried just a few

years before to a drunk just because he went to the right church and they were the only people being allowed into heaven.

My grandmother's second husband, Charlie, was a silver-haired runt. He was an old newspaperman who had lived and worked in the old days at the newspaper in Muskogee, Oklahoma, on the back way from the north down to Texas. Early on he had interviewed Baby Face Nelson and Machine Gun Kelly. When he was a cub reporter, he had interviewed Will Rogers.

Charlie had probably been a drunk then, too, and he fumbled around nervously because Will was one of the biggest stars in America then and was from Oklahoma. Will took kindly to Charlie and took over the interview, saying, Now you're supposed to ask me this, and then I say that, then you come back with this, so on and so forth.

One of Will's quotes was, Eating is underrated because you only go to war once in your life but you eat three times a day.

Charlie was a bitter sarcastic old drunk by the time I got to know him.

And my grandmother wasn't in the moment. She rocked back and forth in time, living on a cocktail of diet pills, church, and the stress of enabling her alcoholic husband. They had a son who was four when I was born: Larry, my half-uncle, walked at ten months and was bright but a brat. He was cruel and abusive like his dear old dad who pitted us against each other.

Mom was scared of her little half-brother and of Charlie and of her mother and of poverty and of Jesus and of uncertainty and that I might be defective, and she worried if her husband would still love her when he got back from Japan and the navy.

When she went back to work, she left me with Dorothy, a woman down the street whose husband was an undertaker and who had to watch too many kids besides the four of her own.

It was stressful there and it wasn't a good place for me. I remember watching TV all day and in the evening sitting, looking out the front window, waiting to be picked up.

But a lot of times it wasn't any better at home than at Dorothy's because my parents were young and so overextended and stressed with Joe, my dad, going to college and working and my mother working full-time.

My mother has said that she didn't see me from when I was six till I was eighteen. My only explanation is that I tried to stay the hell out of the way. Maybe it was Pavlovian; my feet wouldn't take me there unless they had to.

I would come home from school and check the pH of the house—my presence depended on the reading I got.

With all this freedom I would wander around and get into things. The first time I had a run-in with the police I was five or six and I was walking up the grassy alley behind our house. I was inspecting a neighbor's brick incinerator, a roughly three-foot-square open-topped box.

It was missing a couple of bricks and I remember how surprised and proud I was as I dismantled it by hand. Then I

walked around the corner and saw the girl from next door. I made her promise not to tell anyone I had superpowers and if she didn't believe me to go and see for herself.

As fast as her little legs could walk she went and told on me and so the police came to my house.

Around the same time I got a bow and arrow with steel practice tips. I had seen a movie where Indians shot arrows at the sky and that looked like a good idea so I went into our shady backyard and shot my arrows over our house, almost hitting the man sweeping his driveway across the street. That could have killed him.

I never did get in trouble from them for the big stuff.

Now back to Charlie.

I have to be fair and say that he didn't think he was so bad. Like when he would drunkenly tell me about that cold December day when he and my mom brought me home from the hospital and took me all around town, showing me off to people they hadn't seen since.

He could be charming the way a drunk can.

Here are some examples of the joy he brought into my world.

Every Sunday he would manage to get stinking drunk in the thirty minutes between church and dinner. At dinner he'd hog the spotlight, repeating the same things again and again.

One of his favorites goes like this: I'm going to get a farm. I'm going to move out of the city and have goats, chickens, and

cows. . . . Et cetera. Then he would allocate the chores to Larry and me. It was the same thing each week.

This stressed my parents.

And one time my father raged on the way home in the car, saying how would Charlie work a farm when he can't even clip his toenails.

So the very next week when Charlie said, I'm going to get a farm, I interrupted him and said, with my chin just over my plate of mashed potatoes and roast beef, Granddad Charlie, you aren't ever going to get a farm; you can't even clip your toenails.

My father jerked me out of the chair and boy, did I get it.

The next week Charlie was as drunk as always, but he didn't talk about the farm and after dinner he said he wanted to take me and Larry to the Lake View amusement park.

Man, did I want to go.

We had driven past it many times and I had seen the colored lights and the Ferris wheel at night and I studied the ads and I loved the way they looked with the letters all different colors and tilting all funny. It looked like the most fun place on earth, but it cost money and we were short of that.

So when Charlie said he wanted to take me and Larry, my mother looked nervous and said no. I pleaded and begged until she gave in and I ran out to Charlie's big car and climbed into the front seat and sat in the middle where the soles of my tennis shoes pointed straight out at the vents on the air conditioner below the dash. It was a pretty hot day and when we parked in the gravel parking lot, Charlie turned off the car and

looked down at me and I smelled his whisky breath and he said, Look at those shoes. You look like a tramp. I'm not taking you in there.

I climbed into the backseat and watched them out the rear window as they walked under that sign I couldn't read, but I could tell by all the different colored letters and the funny way they tilted that it said "Lake View."

And then I climbed back into the front seat and sat in the middle and waited and looked at my shoes.

RELATIVE

My other grandparents moved back to Tulsa shortly before that. They were still in their forties.

My grandmother saved me with her warmth and my granddad with his humor.

Grandma was old style: she never learned to drive and her only job was being a mother. She was a connoisseur of her children.

She could tell you the day each took their first step, spoke their first words, and every first thing. She could pretty much do the same with her grandchildren.

That was what interested her.

Granddad was one of the last of his type.

From the outside he looked to be cut from the same cloth as someone like Johnny Cash.

But Granddad was taller, smoother.

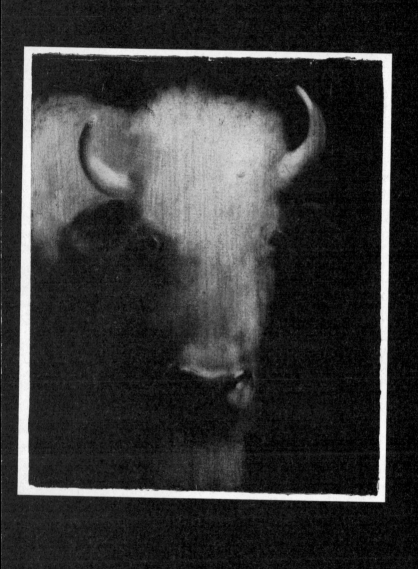

Six foot five and part Cherokee so he always looked tan, with jet black hair. He was charming and a sharp dresser in shined, high-arched black dress shoes, starched wool pants, and light gray shirts. His belt had a tasteful Ranger western buckle. He was a silver-tongued womanizer.

And really funny.

He drove big rigs, nationwide, on one- and later two-lane highways before there was paved road all the way.

To me he was a cowboy, a pirate, and an explorer who told me tales from the frontier.

My grandma told good stories, too.

It was pretty loose around my grandparents' house.

They let me smoke and cuss sometimes, as long as I didn't get carried away or do it in front of my parents.

There was lots of laughter around there.

One afternoon I was sitting watching a Popeye cartoon with my granddad. Popeye was getting his butt kicked by Bluto and just when it looked like Popeye was a goner, out popped a can of spinach. Popeye squeezed it out, and like a fountain, it landed in his mouth.

Popeye's shirt buttons popped off and his bulging muscles made the seams split, and a big sailing ship appeared on his chest, and on his forearms, big cannon tattoos shot cannonball punches fed by the cannonball pyramids on his biceps.

You can guess it didn't take long to send Bluto packing and for Olive Oyl to rediscover newfound love for Popeye the Sailor Man.

Granddad and I were inspired, and I sat up on his lap and

drew a big sailing ship on his chest with a blue ballpoint pen, and on his forearms I drew cannons and then I drew pyramids of cannonballs on his biceps.

Sometimes my grandmother would let me draw on the door of the fridge with markers. And she saved the smooth cardboards from her husband's starched shirts, and all the ballpoint pens he brought home from the road. They all were colorful and had different addresses on them. After school I would sit at the coffee table and draw while I watched the afternoon movie and cartoons in black and white.

I loved the grandeur of my grandparents' optimism.

This was Granddad's perfect fishing trip, as we planned it:

He would say, We're going fishing. We'll leave Grandma at home and pull the car right up to the bank and sleep in it and roll the windows down just enough to stick our fishing poles out.

We'll drink pop, and eat crackers and Vienna sausages. We'll have a good time, just you and me.

We never made that trip but what's more important is that we always had it to look forward to.

We did go to the lake often with the whole clan, on day-long fishing trips. After my grandfather was slowed by cancer he taught me to drive while everyone else was fishing. I could drive okay by the time I was twelve.

My family's best times were when we were rolling in the car looking ahead and not back or at each other. With the Ken-

nedys in the White House the future was ours and anything was possible.

We had a black '57 Chevy with a red interior and a V-8, and gas was cheap so for entertainment we would go to the drive-in movies or drive up to Reservoir Hill and look out over the lights of the city. And turn up Elvis when he came on the radio.

My young family functioned well on the move.

Take the lake. Joe and Lois could fish and they loved to fish.

They would sit in folding chairs looking out over the lake with my grandparents there and the kids within earshot. And this would be the best it ever got for them.

My dad once gave my mother the best compliment a guy like him could give his wife when he said there was no one he would rather go fishing with.

The irony was that she often caught more fish than he did. Here you had Mr. Scientific doing everything by the book, and the gum-popping space cadet with her fishing line lying in a figure eight on top of the water with her bait on wrong—and the fish would rather bite her hook. Dad had trouble finding the humor in that.

To this day I am happiest when I am outside and on the move. I think it has to do with something like genetic memory. You know, like how certain breeds of dogs do certain things.

All the people who came together to make Joe and Lois traveled about as far as humans had ever come in that first wave of immigration before airplanes.

Joe's family can be traced to an island off the coast of

Norway called Andoe, which was home to a Viking tribe called Andoe. The tribe migrated to Ireland around A.D. 800, and later, around 1800, my father's ancestors came to America. One of them, Francis Andoe, set up a dry goods store in Georgia. He had a big family and many of them opened stores around there, and then one of his youngest sons took off to Arkansas with his midwife wife to open a trading post because the Civil War was brewing. Then he moved his family up to Missouri and opened another trading post there and had more kids. One of his youngest was named Bill, and he was the wild card in the Andoe clan of red-headed dry goods merchants.

At some point Bill Andoe dropped off the grid down into what was then called Indian Territory, later the Forty-sixth state, Oklahoma.

There he married an Indian and lived in a dugout house built into the side of a hill. That's where my granddad was born and that's where he got into some bad beans and got so sick that they thought he was going to die so they dressed the four-year-old in a clean nightshirt, stood him on a chair, and took his picture.

I don't know why they could take his picture and not take him to a doctor.

Around the same time he got into the home brew calk beer and supposedly tore the heads off some chickens.

He left home in 1925 at the age of fourteen.

He got by on his wits and charm.

Lois's people came from Ireland, England, and Germany. I don't know much about Mom's side of the family, but I do

know that her great-grandfather married somebody who thought she was above him. He took her out of the city to live on a farm. They had four kids and then a drought came and they were unable to sustain the farm. She nagged and nagged, telling him she shouldn't have ever left the city and moved out with him to this godforsaken farm, and how she deserved better. She left my great-grandfather with nothing to work with— he had no power over the rain—and that's when my mom's dad found his dad hanging in the barn.

Lois's dad was a lot like my other grandfather— charismatic—but smaller, and he looked sort of like Humphrey Bogart. He died when Lois was ten, so I never knew him, but according to reports he was a softhearted guy who never met a stranger. After she lost her daddy, Lois was left with her cold German mother who provided food and shelter, but that was about all.

She still misses her dad and to this day gets strength knowing how much he loved her. She remembers how when he tucked her in every night he would tell her that she was all he had in the whole world.

Lois's great-grandfather on her mother's side came to New York from Germany and didn't know a word of English when he was greeted at the dock in New York and recruited into the Union army and made it all the way to the end of the Civil War with only his collar button shot off.

If the musket ball had been just a tiny bit closer, I wouldn't be telling you all this.

This is a much bigger deal to me than it is to you.

SHE LOVES YOU

I worried about Elvis. Did he see this and what did he think?

I felt guilty because I wanted whatever the Beatles had that first night on Ed Sullivan.

We moved ten times by the time I was ten.

Dad was an engineer and landed a job at North American Aviation, which was working on part of the *Apollo* moon rocket.

Now for the first time we could afford a home of our own. We didn't take shopping for one lightly, and every night we hunted for that perfect place we could afford.

Thousands of new homes were going up in east Tulsa, which is where we found the one.* It was on a new lonely street and we were only the second family to move there, but it filled in quickly with other young families and Gordon's was one of them.

Sometimes you can't pick your friends, either.

* And we had brand-new schools, too.

RATS

Gordon's claim to fame was his sleeping sickness and how he recovered from it. Also that he had killed a wild boar and was baptized.

But my friends Walter and Tom and I thought he was the bore.

Gordon's family belonged to the Freewill Baptist Church and they were preachy.

But the poor kid didn't have anyone to play with in our new sparsely populated neighborhood of tract houses, and we were really shitty to him.

We thought we were too cool that summer because we were into the brand-new Beatles album, *Revolver,* and we hung around inside our houses drinking frozen apple cider and building model World War I fighter planes like the Sopwith Camel—the Red Baron's triplane—and wondered about the seagulls in the song "Tomorrow Never Knows" and the song "She Said She Said," where John Lennon sings, "I know what it's like to be dead."

Walter and Tom were thirteen, but Gordon was eleven, like me.

We told him if he wanted to hang out with us he would have to go through an initiation. Like wade across the quicksand down at the creek, which he did. We shot him with our BB guns in the fat of his fat thighs that showed between where the mud came up to his knees but stopped below his too-short shorts.

He cried but he thought it was worth it.

But then we all went to Walter's house and we made Gordon wait outside until we had concocted a secret potion. We brought the glass outside and told him that if he drank it we would let him into our club.

The glass was full of every liquid and spice we could find in Walter's kitchen cabinet, from vitamins to vanilla to soy sauce to distilled white vinegar to milk and salt and pepper.

What is it? Gordon said.

We aren't telling unless you drink it all.

And to our surprise he drank it all and then wanted to know what it was. We said arsenic.

What's that?

Rat poison.

Then he collapsed, falling off his bicycle onto the grass, holding his belly and crying as loud as he could until somebody called his mother. Later we got it.

But Gordon was a forgiving type. Sometime later I was riding with him in the backseat of his parents' car and he put his father on the hot seat, saying that his dad had seined a creek, which meant he put a net across it and caught fish, and that is illegal, not sportsmanlike or Christian.

His dad denied it but Gordon didn't let up.

He told me another story about his dad. One time at their old house his dad was smoking out some rats from the barn and two rats ran up his dad's pants leg and Gordon laughed about how funny his dad was, dancing around trying to get his pants off outdoors because rats had run up his legs. His dad didn't like that one, either.

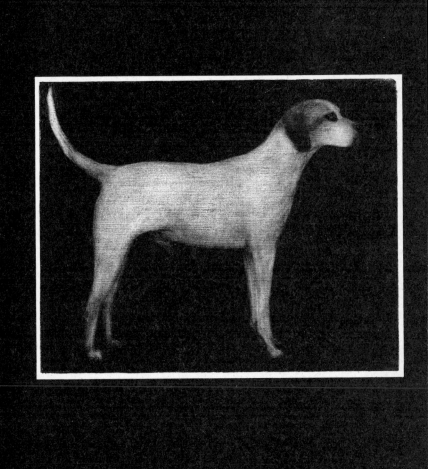

BIG BEN

I got so tired of hearing her talk about her perfect husband and her perfect adopted son partly because I felt sorry for them but mostly I was bored to tears.

Like how when the son came home from college she would go out to his car and check his odometer because she knew exactly how far it was.

Or how her husband refused to wear makeup when he did the weather on TV because "he looks just fine."

This went on every day and we were captive because this was our sixth-grade homeroom teacher.

I would just zone out and doodle in the margins of my notebook and I did some of my best work there.

One day I was jarred out of my dream by her ripping a page from my notebook and rattling it like a crisp flag over her head, then walking around the room and pointing to the silly drawings as an illustration of the fact that I didn't belong in the sixth grade. She then hastily wrote a note that she put in an envelope, licked it and gave it to me, and told the class she was sending me back to the fourth grade.

All eyes were on the back of my blue paisley shirt as I was expulsed from the room.

Walking past the lockers lining the dimly lit hall of the new James Fenimore Cooper Elementary School I tore open the envelope. The note read, "Keep him there until we make a believer out of him." I folded it in fours and stuck it into my back pocket and out the side door I went.

For lack of a better term it was powerfully psychedelic, walking home like this at such an early hour, completely alone and the light was so vivid.

My mother wasn't there so I sat on the porch.

Coming home she was surprised to see me and called my father. Very soon Dad was having smart words with the principal as we sat in his office, the principal nodding his head and reading the note several times before the teacher came in.

I couldn't understand everything they said, but I could tell by the motion I was witnessing that my teacher was getting her clock cleaned.

MY WINGS

In the seventh grade my cousin Sambo came to stay for a while.

My horizons expanded. He was a tall blond kid who was six years older than me and had been through a lot, like being home the night his mother shot herself in the stomach; she died a few days later.

His father remarried quickly and Sambo told me he had fucked his stepmom.

When I asked him what was it like he said, She had good tits but fucking is just okay, and it felt kind of good afterward.

Later, I was all ears when Grandma asked him whatever happened to so-and-so's girlfriend.

He said, Oh she's pregnant, and Grandma asked who the daddy was.

Defensively Sambo said, Not me, we only dated just once.

Well, it only takes just once, my soulful grandma said.

I was thinking, You can go out on one date and have a kid?

Sambo borrowed my grandparents' car and we sped downtown to the civic center to see Three Dog Night, but it was the opening act that captured me. They were a late version of the Byrds who played psychedelic country music and they were cool to my fourteen-year-old brain. This set the template for an ethereal drifting fuckup.

Sometime later Sambo disappeared into prison and child abuse and con artistry.

After twenty-five years, when my grandmother was ninety-two, Sambo resurfaced, and she did not want to see him, being the disappointment he was, but he was coming anyway.

So the night before, she died in her sleep.

She would rather die.

At the end of my grandfather's long, slow cancer death my grandma was exhausted from getting up and nursing him night after night after night.

She decided to let him go.

He was going and there wasn't much she could do at that point except call the ambulance that didn't get called.

She lay there in the next room, quiet, while he was dying.

He cussed her.

He had nicknamed her Dutch.

God damn you, Dutch, you're going to let me die, aren't you?

This went on for hours.

In the morning he was gone and no one said a word to her about her right to choose.

Once toward the end I went to see him like I did a few times a week.

For the first time in his life my granddad was forced to stay put.

He was bedridden and medicated, but he was enthusiastic when he told me, now seventeen, about a news story about hippie communes in Canada he had seen on TV.

He said, If I was you I would grow my hair so long I would have to part it to shit and I would go up there to one of those hippie communes and collect up on some of that free love.

JUNIOR ACHIEVER

I am fourteen and I ask, Am I drunk yet? Adam! Am I drunk yet? I yell toward my twenty-six-year-old friend Adam who drives us out to the city limit one summer evening to get drunk.

For a while now I had tried and tried to get drunk (it looked fun), but it all tasted so bad.

But this time I chugged a whole lot of this half-gallon bottle of cheap sweet wine called vin rosé.

Adam was a family friend of Danny's, and Danny, who was going to be in the eighth grade with me when school started again, was there, too.

I chugged more. Adam, am I drunk yet?

Adam said, Run down to that road sign (about fifty yards away) and then you'll be drunk.

I ran to the sign and then I was looking up close at the crackled old yellow paint stripe and the light gray asphalt as I crawled back and the rest is a blur.

I have a scar from a flickering memory of being caught in barbed wire under supermarket floodlights, then of being blinded by an overhead light. My parents cleaned me up after they found me lying in my vomit.

Suddenly I was awake, sick, thirsty, and lying on a bare mattress in my underwear.

It was right before dawn and, confused, ill, and cotton mouthed, I found my dad dressed for work standing at the kitchen sink looking out the window into the backyard.

Words lacked the horsepower to usher that transition.

It was the birth of my other. My new gear, an alternate personality, and my grandiosity was actualized and attainable.

At last I had mastered the low art of coming unmoored.

CYCLOPS

I saw Jimi Hendrix a few weeks before he died.

I was almost religious about him when I was fifteen, and went with my friend James and his dad, a cop who worked the show.

Years later I learned it was a money tour and Jimi had reluctantly promised the label to play old stuff.

I noticed him playing the old songs fast with no feeling, and he kept apologizing for being out of tune. Only cowboys stay in tune, he said.

The crowd was restless, talking, walking around.

We were in the cheap seats way back in the civic center that mostly hosted the Tulsa Oilers ice hockey team and bush league professional wrestling.

Then something changed. Jimi started playing a new song.

It all pivoted.

Hendrix was out of the box.

The whole place shut up because Jimi Hendrix was fulfilling his promise to us.

James and I rushed up to the already crowded stage.

Shameless, we pushed ourselves to the front, right below him.

The rhythm was a throbbing calamity that Hendrix departed from, first to levitate, then float back on in contrary motion that was like when cold air meets warm and tornadoes are formed.

And it was loud.

I thought about Ben Franklin and the key and the simple way both he and Hendrix manipulated electricity.

Seven huge Marshall amps were at his back with so much current that between songs you could hear waves crashing in an arc over his shoulder. He could just turn and engage it like a bullfighter with his guitar and surf it or crash into it with just a turn of his hips. It's called feedback—the shriek from nature being forced to look at its own death—and it is the sound of huge disappointment and agony.

But to my young point of reference it mostly compared to when Jason from that *Jason and the Argonauts* movie threw a spear into the eye of the giant Cyclops.

Jimi was so close I could have touched him, and I saw him sing with his eyes closed and he was smiling and seamless in those mythical portions.

I discovered Jimi Hendrix's "Are You Experienced?" when I was in the sixth grade. It was just released and I found it in the record bin at the new grocery store in Magic Circle Shopping Center.

I stood in the new store with its bright lights and stared at the three guys on the cover with big hair, striped pants, and eyes on their vests.

A red sticker priced it at $3.47.

This was all mine—but not for long.

And ever since then, anytime I hear somebody talking about Jimi I say . . .

What you know about witches?

And they have to take a backseat.

THE RUNAWAY

One night we heard there were some runaway girls who were hiding out and putting out. They were last seen at a wooded fort on the creek next to the expressway between Rose Dew and the truck stop.

They were seventh graders and we were in ninth, and we had an older kid driving us around, and my friend Danny was on his motorcycle.

We were a pack of dogs on a scent.

We drove around all night and kept missing them as they wandered around also.

We got tanked up on Boone's Farm apple wine and sat in the dark by the creek, out of ideas, wishing they would come back. Danny was still out there, searching.

I heard something so I went up to the open field that was between the car and the fort.

It was dark.

I saw a motorcycle's headlight bouncing through the weeds.

I wondered why Danny wasn't coming straight over to us. I yelled and waved my arms.

His light turned toward me. I hoped he was coming to tell us the girls' whereabouts.

The light came closer and shone in my face.

Then I saw it wasn't Danny. It was a cop with a big flashlight looking for the girls, too.

I ran and ran as fast as I could in the opposite direction and I could see my long shadow running in front of me through the weeds as the light was shaking all around as the policeman ran after me.

I made it to the two-lane and lay very still in the weeds in the ditch.

SWINGING FOR THE FENCES

The first minute of my first day of high school, the tenth grade, I see the cutest girl ever.

Innocent Snow White—black curly hair, blue eyes, a navy first-day-of-school dress with tiny white polka dots.

I ask her to go out to lunch with me and she says yes.

Cool, I think.

But I am fifteen, too young to drive, and out here on the edge of town nothing's close enough to walk to. I don't have a car but I do have a motorcycle, but she's too fair and in a dress and besides I don't have an extra helmet.

I find my pal James between classes and trade my 250 Triumph motorcycle's keys and my license for the keys to his parents' '67 Camaro and his driver's license that says he's sixteen. We look enough alike.

I drive her into town to McDonald's but there's no spark.

We go back to school, and two periods later I get a notice to come to the principal's office.

I don't have a clue why. After all, this is the very first day.

The secretary sends me right in and I see the principal. And a policeman.

The cop looks at me, then at the principal, and says, This isn't the Joe Andoe I gave a ticket to.

In a millisecond I suss out the situation.

I go through my escape files, check out the exits, and come to the conclusion that I'm fucked.

So seeing I can't get around this and I can't just disappear, I devise a strategy to make myself as small as possible and go straight through the center of it.

That's when I say I traded with James Garrett so I could drive to lunch.

The policeman tells me that while I was eating my Big Mac, James was speeding on my motorcycle and got pulled over. He also got ticketed for having only one mirror.

I learned that the law, the school system, the city, and grown-ups in general took real offense to this. And after much hassle with the traffic court and such, James and I had to work at the Tulsa zoo on weekends.

As school was let out that first day of the new year, James and I were smack-dab in front in the no-parking zone, standing next to the police car, handcuffed, as hundreds of hushed students flowed around us like a current of deep smooth water around a stump.

(Sometime it's too late to make a good first impression.)

MY VALUE

I had to work weekends at the zoo. I was fifteen and got arrested for driving underage, so I had to shovel shit from the four corners of the world.

Once a monkey violently pulled my hair up to the bars of his cage and held me there till I poked the squeegee I was carrying between the bars and pounded him till he let me go.

Another time I was working in the nocturnal animal part of the zoo when a ringtail cat bit the shit out of my leg and I kicked it across the room.

The pretty but angry German female zoologist said in a heavy accent, FOOL, ZAT ANIMAL IS VORTH MORE ZHAN YOU!

OPULENT TREASURE

We met outside the east wing of high school in the smoke hole.

It was a bleak and cold windy day when I bummed a cigarette off her.

I was almost sixteen and she should have graduated two years before but had had a run of bad luck.

She told me she was trying to get her life back on track.

I wasn't attracted to her physically. I thought she looked worn out.

But somehow we got close even though we didn't hang out much.

I thought she was cool. She was legendary in east Tulsa and I loved to hear her stories about drug deals and prison.

I respected her wildness and her commitment to it. I could go there but couldn't stay. But I loved to hear the stories from those who did.

She told me how she had got strung out on speed and lost her baby. She said it was because she shot up.

Some of this went in one ear and out the other. One day on our lunch hour she drove me to the pretty tan trailer home she shared with her mother. We smoked a big joint on the way.

Inside it was neat and clean and I followed her into a sunny bedroom. I thought we were going to have sex. She lay facedown across her bed. I lay down next to her. The bed was hard. She asked me to rub her back. Her back felt bony; her bra was like a belt across her spine.

Nevertheless, I was heating up and tried to feel her tit. She pushed my hand away. I rolled onto my back, rejected and stoned.

I noticed the room was full of baby things. New baby toys, a crib, pink, blue, white, and yellow stuff all over.

Then I saw a picture of a tiny pale baby in a lace cap in a white frame on top of the TV set.

She said, Yeah, he's dead. They just took a picture of it for me.

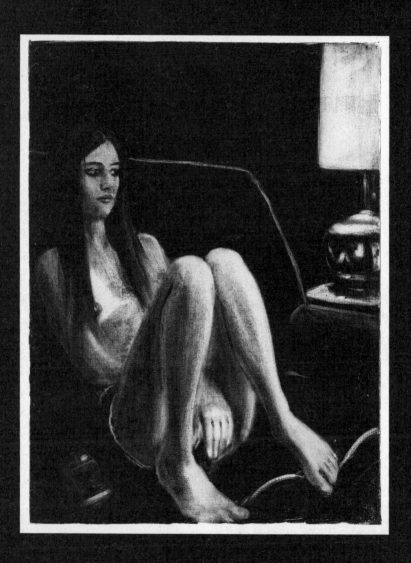

THE GLIMMERING PATH

In 1970, when I was in the ninth grade at the brand-new Stephen Foster Jr. High School, surrounded by new neighborhoods filled with new houses, a new girl showed up from New Jersey. She had a sweet smell and looked like Janis Joplin and during our first conversation she sold me my first matchbox of weed for five bucks.

I smoked it with James but we didn't get high so I went back the next day and bought a hit of acid.

She called it Purple Haze. I split the purple tab with James after first period.

Again I felt nothing. I ate lunch and went outside to sit on the retaining wall under the noon sun.

I was sitting there talking to someone when I rolled back onto the grass behind the wall. I pulled into a fetal position because it felt like I had an ice cube between my balls.

The assistant principal walked by and said, Come to my office.

I sat facing the shiny-faced balding man.

I was getting the "What am I going to do with you?" talk. But the assistant principal did not know that behind him on the white high-gloss painted cinder-block wall were all these spinning pinwheels and colorful explosions.

Suddenly the assistant principal said, Get out!, as if in midthought.

So I went to my algebra (not my strong suit) class, and the numbers in brackets with the x's looked evil.

I could see the veins in my hands through my skin, first red, then green.

I got up and said to the teacher, I think I'm going to be sick.

On the way to the nurse's office I looked into James's classroom, only to see James glowing beyond joy.

What I saw and felt was mine only because I could never explain the horror.

(I went on and did LSD a lot more plus a bunch of other drugs. I did anything, really.)

FILLING DAD'S SHOES

It sounded like the right thing to do. After all, we got short-changed. It was supposed to be a hundred lot and there were only eighty-nine, but my pal Randy and I both took two so . . . that's still not a hundred.

We had gone up to the civic center to find drugs. This party we were at didn't have anything.

We had found some kids outside who sold us the LSD in the restroom in the main hall. We went back when we realized we'd been shorted. The kids were still there. Randy did all the talking since he was a year older than me and he was six foot seven.

They were arguing when a cop came in with his gun drawn. The film canister with our drugs in it didn't flush.

Randy claimed innocence and even got on his knees and mockingly begged the cop to let him go.

All that just made it worse.

Me, I stayed quiet trying to make myself invisible.

Once again the only way out was to go straight through it.

I could have won an award for playing an innocent kid in the wrong place at the wrong time.

The cop took us across the parking lot to the courthouse where the jail was.

The weekend night shift detective was dull. And I was high on two hits of LSD. I was way ahead of him. I had seen this a million times on TV.

By playing dumb and looking my age they let me walk through, but I had to wait until someone came to get me. By this time I was frying.

We were all in the cell together—me, Randy, the kids who sold it—seven of us, six white kids and one black, and we had all dropped the same acid.

We were all sitting on the floor with our backs to the bars and the black kid kept singing the same verse of the same song over and over and over.

Just an old-fashioned love song playing on the
 radio,
Just an old-fashioned love song playing on the
 radio,
Just an . . .

We were so high and he was killing us. We were rolling around laughing for hours on the floor of the jail cell.

I can't see how you could laugh more.

Then the party was over for me because my dad was there.

And, boy, was he disappointed.

We had to wait to talk to someone before we could go.

I sat as he paced.

I held my head in my hands and looked down at the floor to avoid his eyes. And I watched as with each step his feet got bigger and bigger until they were huge.

TIRE PATCH

One night three other boys and I were sitting in a car in a low-rent apartment complex parking lot when the boys in the front seat turned into monsters and looked back at me and laughed as I stared in awe at the stockade fence that was backlit by a streetlight silhouetting its bottom and top teeth that were jagged and gnashed angrily and moaned as I sniffed glue for one of the only times.

(Let me tell about somebody who lived there.)

CAT FISH

Mom says all you have to do is take me to school and bring me home, that's all. She wants you to treat me well, too. And if you do that she won't tell your folks and you won't lose your car.

I was now sixteen and had just got my first car and also just got Marla pregnant.

She wasn't sixteen yet.

She and her single mother lived in the low-income apartments near the expressway.

Marla and her mom had gone back to Kansas to get the abortion and now I was holding up my end of the deal as I pulled into her parking lot and honked.

This was the first time I was driving her to school. She ran out. I hadn't seen her in a few weeks and she looked different, even better.

Her already big tits are now huge and she is braless in a halter-top. Her fifteen-year-old body still thinks it's preggers, and her tits stick straight out like torpedoes. We speed off.

She enjoys my attention while I enjoy her view.

And I hit the rear end of another student's car as he's waiting to pull into the school parking lot.

Marla slams into the windshield.

The front end of my VW bug is crumpled and the windshield is smashed and I am stunned, whip-lashed, and in shock. It's really quiet but my ears are ringing and kids' faces appear in all the windows, their mouths opening and shutting but I can't hear them.

She slides halfway to the floor and the top of her head is pointing toward me. I'm looking at her face upside-down as her eyes roll back and her mouth moves but nothing comes out.

I remember sitting there thinking she looked like a cat fish.

(Marla's mother never asked anything of me again.)

My parents bought me a new windshield but I was going to have to live with my car otherwise.

The day I got it back I had no money so I went out and tried to scrape some up.

A friend had an idea. We went to collect beer cans from behind bars to turn them in for the deposit money.

Sure enough, we found lots of cans and quickly filled my bug.

We were heading fast, about sixty, toward the place where you could cash them in when my front trunk lid flew up and smashed my new windshield.

I cried.

My dear sweet parents bought me a '67 Nova.

I liked its looks—maroon with chrome reserve wheels.

I fell in love big time when I heard its engine. *Vrr-rooommm.*

A 283 V-8 in a smallish car always hauled ass.

OUT ON THE PERIMETER

We lived out on the east side of Tulsa, where the edge of town starts again before it stops. The high school I went to sat on old Route 66, which was bypassed years before. Along that road, mixed in with defunct highway businesses, were little farms with horses, and farther out were fields where as teenagers we would go and hang out in our cars and get high, talk shit, or have sex, under three really tall radio towers that twinkled red lights at night. Sometimes horses would come and stand next to the cars and sometimes they looked in.

We all took pride in our cars and motorcycles. They were American. Made in the '60s, most of them were medium-sized with big V-8s. The style was just under stock—clean, stripped down, and sometimes not even painted. We always had good stereos and the cars were fast. My bike was a Sportster.

Our predators were the police. At times the cops patrolled the edge of the town like a border.

All of us had police records; some were even longer than mine. Before I was sixteen, I got busted for acid and was jailed overnight on two hits of it. Then I got arrested for driving underage and had to work at the zoo. At sixteen I got a car that I totaled and went on to total three more and was charged with DWI, DUI, and reckless driving. I was busted for drugs three more times before I was done being a teenager.

This was just the way things were. I didn't know any different. I knew it was bad and it drove my folks crazy.

HEAD CASE

It was raining as I drove up the long gravel driveway to Adam's trailer house to see the damage. The house was outside of town secluded on a few acres of scruffy trees on the edge of a muddy plateau with a great view.

Adam was twenty-eight and we were all about sixteen. He had been left behind.

He was a childhood friend of my friend Danny's big brother. But Danny's big brother had moved away and was driving trains and raising a family.

Until recently Adam had lived at home, and now he worked where his dad did at the phone company, which had great benefits so Adam could spend his spare time driving around, going from doctor to doctor looking for someone to write him a good scrip. He would take anything.

A lot of the time he didn't know what he was taking. Once it was birth control pills.

Plus he was kind of mental. He said he heard voices and often acted silly and totally insane, like the time he jumped up on a Foosball table at a teenage arcade and barked like a dog in front of the whole place.

We thought he was a lot of fun and would laugh at him until we almost peed our pants. He bought us booze and shared his drugs with us.

We hung out at his new trailer where we could do anything, like bring girls there and get as high as we wanted.

Adam never got around to doing a lot of things, like tying

down his trailer and so sometimes the wind would tilt it, almost blowing it over, and we thought that was funny, too.

I had been there a few nights earlier when this kid named Kit Frank brought in a paper sack half full of yellow jackets, barbiturates that someone had stolen from a pharmacy.

I held it and it felt like a pound.

That's when the fun started.

But I didn't stay because I was already in trouble.

So now a few days later I'm back, and this is what I see: Adam's new trailer home has all the windows broken out and the front door is wide open. There are big dents in the siding, and out front, in the mud, are all the furnishings—the dishes, and his mattress, and the sofa, and all his clothes and pillows, even the wall-to-wall carpet—all outside in the rain and mud.

This is what I was told had happened: after I left they kept partying, taking those strong downers until they blacked out, and when they woke up they took some more. It was like flies on shit. Kids came out of the woodwork and for once there were enough drugs. It was a big crash and burn scene.

That lasted for days.

In that time Adam lost his job and wrecked his car. And then this happened. You see, Adam didn't have good refusal skills so when Fat Jimmy Walker and his younger sidekick Tall Larry Hall showed up too late wanting drugs, Adam wouldn't answer because he was scared to death of telling the two baddest speed-freak criminals on the east side that he was out and didn't have any more. He just watched as they broke

all his windows with big cinder blocks and hammered the blocks into the side of his trailer, leaving big dents, before they broke in the front door as he jumped out the back and hid in the bushes in his underwear. They threw all his clothes into the mud, then tore up all the cheap trailer furniture that came with the place, then threw it out the door along with the dishes, pot, pans, food, and his bed.

Then they ripped up all the wall-to-wall carpet and dragged it into the yard.

Exhausted and pissed off about not finding drugs, Fat Jimmy Walker slapped the younger Tall Larry Hall, then took him by the wrist and spun him around one full time before ramming his head into the trailer leaving another big dent.

Not too long after that Jimmy Walker found what he thought was Davy Jones's locker when he broke into a veterinary supply and came away with something he called Blue Morphine.

So sweet and special he would not share but he teased his friends saying how little you need and how deep was the sleep.

Well, it put him to sleep.

And it was found to be the stuff you shot dogs with to put them to sleep.

That was a long time ago, and Jimmy is still asleep.

BACKSEAT

One afternoon in 1972 my girlfriend Kay and I were in the backseat of my car in a field off East Eleventh Street (Route 66) when a horse looked into the window.

LOW RENT

Out near the roller rink on a mile-long stretch of East Admiral in the middle of the low-rent universe is the trailer home sales center of the region.

One mile of dealer after dealer of mobile homes in every configuration—double wide, new, used, high and low.

Sometimes in junior high we would leave the roller rink and go and hang out in the trailers that were left open and easy to get to.

Some of them were fully furnished with cheap stuff.

None of the appliances or lights was hooked up, and the trailers were tilted and hollow, like giant empty shoeboxes sitting on the ground.

Sonny Teagarden was this wild-ass kid who was hyper way beyond high spirits thanks to pharmaceuticals. He had no money but he did get the idea to shack up with his girlfriend in one of the empty trailers.

They would come and go at night, sneaking out the back way in the morning, choosing a different trailer every time, in rotation.

This worked out fine for a few weeks until one morning they were awoken by a saleswoman and her clients standing at the doorway of Sonny's borrowed bedroom. Sonny ripped out of bed naked and beat up his three shocked intruders.

That was thirty years ago and Sonny still doesn't pay rent because he's still in prison.

THE EDGE OF NIGHT

Paul was this kid in my twelfth-grade art class.

He was one of those people you only see a smidgen of the time, but it's a consistent smidgen.

I really didn't know much about this tall, quiet skinny kid with long blond hair, except that he didn't talk much and was a good listener.

I did know he had older parents and they lived in a more established neighborhood out by the radio towers. And that he was an only child and a solid citizen.

We sat at the same table in art class and he watched what I did and got a kick out of my work and the stories I would tell.

It was toward the end of our school year and my sixty-five-dollar tax return showed up right before spring break. And so in that art class the Friday before the break I mused about how I would like hitchhiking to Mexico, since now I had some cash.

Paul perked up and said he would like to go, too, and right then and there we made a plan to take off the next day.

It didn't sound like a good plan to my parents. But the following day I went to Paul's house. He'd told me he had backpacks and sleeping bags we could use. It was the first time I'd seen him outside of school.

Out in the garage Paul showed me his canvas Boy Scout backpacks and sleeping bags. I remember noticing that they were adult size, and that meant it hadn't been too long since he'd been a Boy Scout.

I didn't know any Scouts in high school.

I met his mother and she was a tall, thoughtful woman with short hair and glasses; she looked like she could be a schoolteacher. I could tell she was worried about our plan but, like me, he was going anyway. I could see she hated to see him go.

It was early afternoon when we walked out to the road, stuck out our thumbs, and headed south.

It didn't take us too many hours to make it into Texas. We got picked up by two college guys who were going down to the Gulf on their spring break.

We stopped around midnight in Dallas and slept under the bushes in Highland Park, right in the middle of town. Early the next morning we were back on the road and on our own again. This time we got picked up by an odd middle-aged man and a teenage boy. And they were smoking weed.

And we got stoned and lost and took the wrong turn in San Antonio and ended up on the road to Laredo, which borders

on Mexico. We wanted to go to Brownsville, the border town on the Gulf.

It was after nightfall when we were left at the border looking out over the Rio Grande into the third world.

It looked spooky over there and the light seemed dimmer. Then we saw our first lowriders—those low cars just an inch off the street, their radios playing what was weird music to us. Without saying anything we crossed the road, stuck out our thumbs, and headed back north.

We got picked up by a hippie woman in a VW, and she drove us across the bottom tip of Texas to a town not too far from the Gulf. Her house was here, she said, and she told us we could stay the night. We drove down a long dirt road and stopped at a house out in the middle of a field. And she said, Wait here, and went inside and we heard her talking to a man. He looked out the door at us, and we could hear them arguing. When we heard him say, What in the hell did you bring them out here for? we put on our backpacks and walked back out to the road, with the sound of their argument fading, and stuck our thumbs out.

Around midnight we got picked up by a young couple who took us to their '50s-style house that was surrounded by tropical foliage. We walked in and there were ten or so kids our age sitting around, and the TV and stereo were on. The smell of weed was thick, and there was this guy sitting at a table under an overhead light in the kitchen, crying out loud. *Booooo hooooo*, he bawled. No one seemed to notice or care.

I sat down across from him and asked what was wrong.

He stopped crying long enough to say, I ate a lid in a pancake.

He had eaten an ounce of marijuana in a pancake.

What's that—a hundred times the normal dose?

These kids were great and they offered us their floor for the night. I felt like our trip had slowed down and I could see it better.

I remember the salty hazy damp air the next morning as we hitchhiked to Padre Island where we found a bar and a place to lay our sleeping bags on the beach. That night we saw phosphorous glow-in-the-dark waves.

Two days later we started home. Hitchhiking north was like swimming upstream; the rides were shorter, fewer, and farther in between. We spent the first night of our northbound trip stuck on the main interstate somewhere between San Antonio and Austin because no one would give us a lift. Traffic was sparse and it was cold, and we took turns standing lookout while the other lay on the warm pavement of the inside lane so we both wouldn't fall asleep and get run over.

I remember that I was lucid and in the moment, and how flat and warm I-35 was against my back, and how big, wide, and deep the south Texas sky was and how I had never seen so many stars, and how I had never been so free.

I was happy to get home and I was glad I went.

But right away Paul got together with his buddies and they conspired to go back south to re-create the "great time" we supposedly had.

That was the very last thing I wanted to do.

From what I heard later, their trip made ours look like a walk down easy street.

Too many people went, they brought too much gear, and one guy had a motorcycle that had too many breakdowns, and they got too wet from too much rain. One of them even had to take a bus home to get a van to come back down to Texas and rescue the motorcycle and the rest of them.

I don't remember seeing Paul after that other than once, briefly, and I could tell he was no longer that quiet kid who had just been a Boy Scout whom I knew from art class. He had moved out of his mother's house, living large and taking chances.

Early that summer after graduation I got a motorcycle and I guess he bought one around the same time. He started to customize it into a chopper but he didn't weld the frame so it would ride level. Instead it rode like you were going uphill, making it unstable, but he rode it anyway. His buddies got motorcycles, too.

One day only a couple of months after our trip Paul and his new girlfriend and a few other guys rode out to the lake. And of course they were drinking and riding and having a good time cruising along the curvy, hilly roads.

It was a pretty day and they were rolling and Paul's girl-friend was riding with him, leaning over him, lying over his back and steering as he bent over the gas tank, drinking a can of beer through a straw. Her arms were fully extended, holding on to the handlebars and the throttle, her chin resting between his shoulder blades. I guess they had done this before.

Then she took them around a curve, but she was going too fast and she hit the tire of the cycle in front of them, and Paul's bike went down and slid into the oncoming lane and then Paul sat up and never saw the truck that hit him.

I heard it hit him hard enough to knock his eye out.

Paul's girlfriend walked away.

I went to his funeral and felt numb, and also embarrassed and somehow responsible. I knew that my musing that day in art class, not even three months earlier, about going to Mexico was the stone that landed in his clear pond and rippled his smooth surface and resulted in Paul lying in that box under this awning in the middle of the hot, treeless graveyard.

And me, standing there with sunglasses on, thinking everyone knew it.

I didn't like me that day.

Then it was over and as I walked to the edge of the cemetery, there was his mother. It was the only time I'd seen her since that first time.

And she wasn't crying and didn't say anything, but just gave me the most curious look.

(I'm sorry, Paul.)

KAY

My first hour of the first day of my senior year I am sitting in algebra and all the way on the other side of class in the front row was this super-duper cutie, a cutie in just my style.

I fell in a love like never before or ever since.

She was mine.

PRINCIPAL

It was a bright Sunday morning when my sweetheart, Kay, called me. She said, Come over and beat my daddy up 'cause he tore that dress off you bought me and ripped it to little pieces before church.

I had bought her a hippie dress made of batik on muslin.

Her dad was as straight as they come—a principal of an elementary school and a deacon in the Methodist church—and he could do many push-ups. He had three very pretty daughters and no sons and he said his favorite was Kay.

I was eighteen and I sped up to their ranch-style house and I walked in to meet a very surprised father.

I said, Mister, it's time for you and me to go out to the yard.

We went out front and squared off with fists high.

Come on and hit me, said the dad.

I said, You're a sick fuck.

Come on, son, let's go into the back.

He said that because of all the neighbors had started to gather.

I started to think this wasn't such a good idea. I hadn't remembered Kay's dad being so big.

Let's go to the backyard, we can fight there, the dad says again.

Now I am the only one with my hands up and I say, You're a sick fuck for tearing her dress off like that.

Then I see Kay coming to the front door. Oh, how I love her.

And she opens it just a crack and says, Joe, you leave my daddy alone.

There was a mimosa tree that faced their front steps and where the fast-growing tree split into a Y it made a small crotch the same proportions as one of his daughters if she were naked and standing on her head.

Without a word he cut it down.

I went to the lake at the end of school and got drunk and cheated on her with one of her friends and she left me.

At least I was out of school.

I didn't want to go to college. I wanted to do real work, earn a real man's pay.

I wanted to be one of the long-haired tan construction workers I saw building those new homes out by us.

1974

I was a few weeks out of high school working for a middle-aged swinger named Charley.

He was sorta short, sorta fat, was dark with a big mustache. He was forty-five and a pretty good stonemason.

Charley had a partner named Dale who was twenty-seven and had been to 'Nam. He didn't talk about 'Nam. He said no one who'd been there talks about it. He was tall and suntanned and kind of pear shaped.

I found out the very first day that Dale was living with the love of Charley's life, Lee.

I never saw her but I pictured a pretty forty-year-old woman.

So on that first day Charley was working on one side of the house putting up stone and Dale was on my other side.

My job was to bring them rocks and mix the mud, which is the mortar between the rocks.

Fairly quickly Charley told me that Dale was living with his ex and that he had fucked her every which way and this bugged Dale.

But on one of my trips to his side of the house, Dale told me that it killed Charley that he now lived with Lee.

Later I went with Dale and Charley to the 7-Eleven convenience store for lunch. I got a hot sandwich from the hot box and a quart of cold milk.

We sat in the car in front of the store and ate.

Dale said to Charley as they chewed that Lee woke him up by sucking him.

Charley looked sick and quit chewing for a second.

It turned out that for Charley, getting woken up that way was his biggie, along with little boys dressing up like girls (although I don't know if he ever got past those little paperbacks on that one).

Charley had a new girlfriend who was a prostitute who worked near the turnpike gate right across the county line in a trailer compound. But he was his own man and did what he wanted to do, so on Friday nights he would go to a singles bar in a strip mall where he would take a hundred-dollar bill, break it, and lay it out in small bills in front of him. He said he could always attract a lady or two that way.

On rainy days we couldn't work so Charley would pay me to drive him around and see his people and drink Coors tall boys.

Once we went to his girlfriend's dad's apartment and we drank tall boys all day long, starting about 9:30 in the morning.

The dad's name was Lenny and he looked old to me. He was skinny and had greased-back hair and lots of tattoos.

We got smashed and I drove because Charley had no license.

He guided me to some apartment where he knew where the key was hidden.

I followed him in.

It was nice and clean and orderly. No one was there.

By now he was really drunk. He systematically broke everything in that apartment that would break. He carefully removed each record from its jacket and broke it. He put his hand on the mantel and slid it from one side to the other, knocking all the objects to the floor.

He opened each kitchen cabinet and scooped out the dishes and smashed them on the floor. He did the same with

the refrigerator—jelly, honey, pickles, milk all in a gooey mess on the linoleum.

All the while I stood there and watched, afraid to move.

When he finished I took him home like nothing had happened.

The next morning I picked him up at eight and he and his girlfriend were sitting in their sunny living room drinking coffee wearing sunglasses. He had done the same thing to their kitchen. Then he had beaten the shit out of her and made her crawl all evening on her hands and knees, calling her a bitch dog; Come here, bitch, and suck my dick.

He told me that he liked to make her crawl around the house and suck him as he drank and read his dirty little paperbacks about boys dressing up like girls.

Around the same time, the movie *The Exorcist* was out. His girlfriend read all those types of books, and one night while they were sleeping, she suddenly sat up in bed and pointed to the open dark closet and screamed, There he is, there's the devil!

That scared the holy crap out of Charley.

So he climbed on top of her and beat her dearly.

This was about the time I changed my mind about college.

(I never found out whose place that was. But I found out how tough entry-level construction jobs were.)

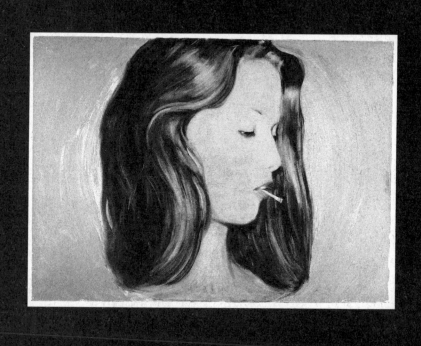

EIGHTEEN-YEAR-OLD STUCCO
LABORER AND WHITE CROSSES

Fucking hot and sunburned finger raw. Then taste that water, it's too bitter to drink but I gotta, it's all we got out here. Suddenly everyone is the boss. This asshole working next to me said, You're fired. I said, Fired? You can't fire me, you ain't my fucking boss. We got the same job.

I was climbing down and I fell.

Just then the real boss walked by. He said, Get off your ass.

I thought to myself, What are you going to do, put more speed in the water?

(Those brutal jobs made the weekends sweet!)

SPONTANEOUS RADIANCE

At the lake we all looked alike, the same long parted-in-the-middle sun-bleached hair, same tan cutoffs, and all underage. The girls wore tube tops.

We came from the east side in pickups, muscle cars, and if we were lucky, Harleys.

Our sports were sex and drugs.

It was perfect and the lake was, too.

Once I showed up in a new gold Monte Carlo.

Everyone hated it but me.

It was too new and too gold.

Trouble started when someone put downers in my Miller High Life.

I poured it out because I needed to be responsible.

But someone slipped me a Mickey because around dusk I could hardly walk.

But I wanted to go for a drive in my new car.

So I enlisted two of my oldest friends who hadn't refused anything and were just as bad off as me.

We got in the car and I turned the music way up.

It was getting dark and going around the first turn I nearly ran over a pedestrian and he shot me the finger.

I stopped and got out to defend my manhood and never landed a punch.

Knocked cold.

My friends dragged me back in the passenger side.

No one noticed when I woke to the sound of the very angry pedestrian yelling through the passenger side window over my limp body to get me out of there.

There was yelling from the back to *go go go*.

Kurt was the driver now and he could hardly hold his head up, much less drive or even find the ignition.

But he did, so the engine revved high as Kurt looked for the gearshift, the pedestrian was still yelling over me, and my friend in the backseat was still yelling *go go go*. Then, surprise! I reached up and grabbed the pedestrian by his shirt with my right hand and swung wide with my left and hit him

as many times as I could before he fought back, getting half-way inside the window, fighting and running beside the car before he rolled and Kurt sped my new Monte Carlo burning rubber into a tree and I burst the windshield out with my head.

I was more awake than I'd been all day.

I saw that my car still had one working headlight and it pointed up. The other was smashed to smithereens, along with most of the car's value.

I told my friends to leave before the law came. And then I threw out all the bottles I could find as blood dripped down my face.

The highway patrol came and found pot and papers in the ashtray and a couple of bottles that I hadn't seen.

The cop took me to the big old territory yellow sandstone courthouse more than thirty miles away near the Arkansas state line in Stilwell, in Adair County.

The jail was deep in the cavernous old courthouse where I was eventually led to a big cage full of men.

It was Saturday night and the cell was full.

Being the youngest, I had to sit in the least desirable place, against the bars near the stopped-up overflowing toilet that was being tended to by an old crazy-looking homeless man who was using his foot as a plunger and pacing back and forth, talking to himself, tracking shit and paper.

There were Cherokee and Seminole Indians in various conditions. Some were speaking Indian to each other. Sitting

next to me was a friendly Indian man who told me I looked like a raccoon because I had two black eyes.

He said, I bet you wish you weren't here.

He got that right. I hated it.

My long hair was matted with blood and my T-shirt was nearly totally red from my bleeding head. It was cold in there and I didn't sleep but when coffee came at about 5:00 A.M. I had to take my T-shirt off to hold the tomato sauce can because it was too hot. Prisoners came out of the shadows; I didn't know there were so many in there.

Then they started to take some of us out. Each time someone was released there was a big flurry of messages to tell the outside world.

When they came to get me, I forgot the messages that I was supposed to deliver. As soon as my back was turned and the jail door shut behind me I walked toward the light at the front of the building. I stepped into the bail bondsman's office. I was blinded by the sun, but I could see the horror on my parents' faces as they saw their bloodied and battered son.

My mother broke out into the biggest tears as my father stood over her with his hand on her shoulder and at the first opportunity he said, Honey, why don't you go down the street and get a piece of pie.

BIRD SONG

Eddie was an Arab who came to Tulsa from the Middle East to study airplane mechanics and dropped out. But he stayed in Oklahoma and now was a stonemason working for himself, putting up stones on new homes in the fall of 1974.

Three other friends and I worked for him for a few weeks. We couldn't understand a lot of what he was saying, like his last name that sounded like "milkshake." He couldn't speak English too well but that didn't stop him.

Nothing much seemed to stop this thirty-year-old "Eddie Milkshake," or "Blockhead Ed," which we sometimes would say to his face because he couldn't understand us, either.

He had a short fuse and he was way different and a long way from home.

Americans were way different to him, too.

One hot day on the rock pile the radio started playing "Stairway to Heaven" and he jumped off the scaffolding, ran over, and turned the radio off, then threw his hands up in disgust.

He said that he had once had a beautiful hippie girl at his place. They had met at a park, and they were just getting ready to close the deal when "Stairway to Heaven" came on. Then she got out of bed and sat next to the radio with her head down, all moody.

And she didn't come back.

Eddie said, That's a stupid song.

CRANKY

We couldn't get off, plus neither James or I had a car that was running.

We left Dale, my boss's, boring party and stuck our thumbs in the air.

We caught a ride with two sixteen-year-olds from the other side of town in a nice Trans Am. The sixteen-year-olds were high on speed and they wouldn't shut up, but they did hand us two fresh beers from a brand-new case.

They talked and talked, both talking at once as James and I, now both irritated, devised a plan to take their beer.

When we got near our destination, we told them to pull down a dark side street.

When the car stopped, we got out on both sides and kicked the kids inside the low car until they gave up their beer. Then we took off and carried the three six-packs for about five minutes until we dropped them in someone's front yard.

We walked toward Peoria Avenue, a strip where kids drive up and down, back and forth. It was always our last resort.

We got separated and six hours later it was almost dawn and I had been walking for miles, unable to get a ride and only a mile from home.

I was a lot more tired than drunk when I finally got a ride.

Happy, I got into the backseat and the car took off just as I saw it was them—the kids we kicked the shit out of—and two more of their friends. I jumped out of the moving car and

took off running. Looking back, I saw two cars, so there had to be about seven kids after me. There is nothing like the feeling of running from a group of people who want to hurt you.

I ran into the parking lot of an abandoned strip mall and in minutes I was surrounded and backed up to a big aluminum light pole in the middle of the lot.

Some of the kids were taking their belts off (like stupid kids) to whip me with the buckles or wrap around their knuckles.

They closed in then. I could see they were scared. I looked down and picked up a big piece of asphalt and held it over my head and said, I'm going to kill the first motherfucker who touches me.

(How did they find me?)

IT DIDN'T HAPPEN

Hey, James, do you remember on your eighteenth birthday we had fake IDs and watched go-go dancers at the Golden Hurricane and got so drunk that I don't remember how you got me home, and how you crashed into a telephone pole at sixty miles per hour not even a minute later right down my street, and how you ruined your forehead on the windshield and shattered your thigh on the steering wheel and you almost bled to death, and how I would have been killed if I had been there?

How about the time we were hanging out across from Union and my cousin Billy was fighting some guy and we beat

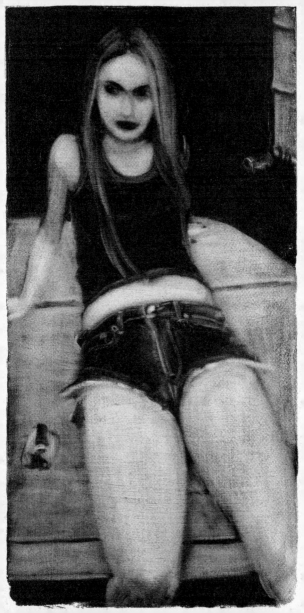

him up, and I kicked him until I was tired, and how he looked crawling bloody in our headlights as we backed out? Then how days later he found me hanging out in the Pizza Hut parking lot and he got out of a pickup with a crutch and a twelve-gauge, and how big and deep that barrel looked up in my face like that, then he asked me if I was me and I swore I wasn't and how easily he could have killed me but . . . ?

LOST IN THE WOODS

I enrolled in Tulsa Junior College and one day spotted this girl going up the escalator as I was going down.

Terry wore a cute shag haircut and was from the wealthy side of town. This was okay with both of us for a while, until she found out just how okay it was with me and her rich girlfriends.

She liked my pickup truck and my farmer's tan but so did a couple of her cute shiny friends who lived in those big houses and drove nice new cars.

We lived together for a while in a place she scored behind a huge old Tudor, in the servants' quarters above the garage under big old trees in the best neighborhood in town.

She caught me messing around with her girlfriends and she got rid of me and kept them. But we got back together and I would stay there sometimes.

TRUDGE

Near the Arkansas River under a canopy of trees in eastern Oklahoma close to Tahlequah is the cradle of the five civilized tribes and the end of the Trail of Tears, and where I rode to on the back of a superfast Kawasaki 900cc two-stroke motorcycle with Mark Ski, this guy I was working for.

I had a great time up there hanging out with my friends Dobbs and Stetson from the east side who happened to be there, too.

We all got drunk and good and high from the homegrown weed that area is known for.

The sun was getting low and we were messed up, riding double with no helmets, just goggles and T-shirts and cutoff jeans.

And about seventy miles from home.

We headed west on a nearly empty two-lane directly into the setting sun. It was right there in our eyes. I could barely see yet my driver kept going faster and faster until everything was going by in a blur and the pitch and the vibration of the motorcycle were very high. I was hunkered down behind him out of the wind as our speed increased and he passed some cars still faster and then it looked like we ran a stop sign.

This sucked.

The motorcycle was screaming now and I wanted to know how fast we were going so I looked over his shoulder and I was blinded by the sun and the wind jerked my head back.

Hunkered back down I worried about how he could see. I tried
again and very carefully peeked over his shoulder with the
sun right there and the wind and I caught the briefest glance
of the needle straining at one hundred and fifteen miles per
hour when my goggles flew off and I turned to see them fly. I
saw a giant white '57 Coupe Deville on our tail so close you
could touch it and it was extremely well lit and I could see the
passengers way too well. I saw my shadow on the car's hood
and the eight passed-out-drunk teenagers behind the bluish
tinted sun-blasted glass of the old Cadillac that was being
driven by a drunk kid squinting one eye to see.

(I was in way too many of these situations and devised a
plan that if I had enough time, just a half a second, I could
catapult at impact and hopefully land and roll.)

WARM BLANKETS

James and I had worked outside in the sun laboring at differ-
ent jobs all summer long and we were baked.

It was Friday evening in mid-August and we were heading
to the lake to meet up with our friends and sleep on the ground
next to the car and our ice chest.

It was toward the end of one of those summer days when
the shadows are long and blue.

But first we wanted to go to the speedway at the fair-
grounds, to try to get a look through the fence at the big con-
cert that was there.

We smoked a joint and pulled up to a late-day yellow-lighted sunny spot in the fire zone next to the sixteen-foot-high fence that surrounded the stock car track. We stuck our noses into not only the fence but also the shade that was coming from the grandstand casting that blue shadow over the crowd in the center of the oval facing east toward the stage where ZZ Top was playing the song "Waiting for the Bus." Right as that song was ending about a dozen long-haired kids came out of nowhere to the fence around us, just as Billy Gibbons said those magic words, "Jesus just left Chicago and he's bound for New Orleans," and all fourteen of us climbed the sixteen-foot-tall chain-link fence impulsively before he was done saying that.

I was not thinking about the car, sitting there in the fire zone with the keys in it and the windows down and all our stuff sitting out. And there was nothing I could do when the crotch of my jeans got caught by the little spikes on top of the fence and I got stuck.

But it sounded great up there and I had a good view of the stage and the whole place . . . and of all my fellow climbers who didn't get stuck, including James, who were being rounded up by the cops who had gathered below us, and of the one climbing up behind me. And so I got unhooked and climbed down onto the track where a lady cop, who had run out of handcuffs, grabbed my arm and had to walk me and her other prisoners across the tilted track near the center of the oval to the grandstand. When she let go for a second, I ducked into the crowd and crawled on my belly around legs and picnics to

the front and center stage where I was applauded and covered from view.

(I saw James again inside and he told me they had taken him outside and let him go, so he moved the car and climbed under the fence this time.)

WISH BONE

Sometimes it's strange what's important. Like the time James and I were at the lake and it was raining and it was early morning and we smoked a joint and were drinking and we wanted to stay that way. But we had just a few beers left and James had a half-pint of Jack Daniels, so we were pacing ourselves because we didn't want to run out before the store opened at noon so we could get more beer, but it was all for jack because it was Sunday.

Shirtless, James went out from under the state park picnic shelter to his Chevy to light his cigarette with the car lighter.

He skillfully held his half-pint with his fingers as he lit his smoke.

Then he took a few precious swigs.

He got out of the car, put the Jack Daniels in the back pocket of his jeans and closed the car door, and started sliding slowly back toward the shelter when he noticed his car was rolling.

He quickly opened the door, jumped back in the car, and put it in gear as something popped on his butt.

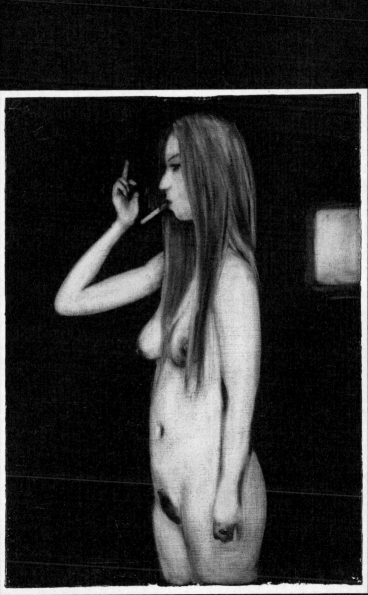

It was warm and wet.

Pale, he looked at the rain on his windshield and said, My God, I hope that's blood.

BANK OF TULSA

I hadn't heard from Kay in more than a year except for the occasional late-night long-distance call from Minnesota when I could hardly hear her and sometimes she wouldn't speak. Lots of times I would wake up in the morning with the phone beeping off the hook next to me.

She was sensitive beyond my comprehension.

Suddenly she was back and said she wanted to see me.

I was wary because she had destroyed me in the way only your first love can.

I wasn't living with Terry anymore but I stayed at her house a few nights a week.

And Kay knew this, but we went to Cain's Ballroom anyway and danced and drank to a country band.

We had a good time but it was a little strange, like she had something to tell me but couldn't.

I took her back to the crummy place in a bad part of town where she was staying with friends, behind an appliance store that faced the cross-town expressway.

I pulled up in front of the place and I didn't turn the car off and she asked, Aren't you coming in?

I said, No, I have to go see Terry, remember?

I was trying to be good.

Her door was cracked open and the interior light was on.

She looked at me in a very disappointed kind of way that brushed up against disgust, like she was trying to tell me something but couldn't put her finger on it.

She lit a cigarette, then got out and slammed the car door. She passed in front of my headlights that were shining on the wooden steps going up to the front porch that she *thump-thump-thumped* up before she slammed that door, going into the house. I backed out and went home instead of to Terry's.

The next morning my mother woke me up saying that I had a phone call and I looked at the clock and it said six. She whispered loud, It's some man.

Hello, this is Henry Wilson, Kay's uncle, and I'm sorry to tell you that Kay died in a fire last night.

Sleepy, I said, No I, I just, I just . . . You're kidding, right?

No, he said.

I begged, Please, don't tell me that. No, you can't say that. Please, tell me this is just a joke.

Son, I wish I could.

(**They** didn't really know what caused the fire. Maybe it was the gas heater they said.

I thought she might have thrown her cigarette down and it bounced out of the ashtray as she went into the house in her huff.

But they found her in the kitchen behind the refrigerator that was blocking the back door.

Maybe she couldn't put her finger on it but knew deep down somewhere that she was going to need help with that refrigerator.)

PLANTATION

I hurried painting my great-aunt's house's trim.

I didn't do a very good job but she paid me and I took off in my truck on the two-lane heading south when it started to rain and the car in front was going slow and I tried to pass it, almost hitting a highway patrol car coming the other way.

I saw it turn its lights on and turn around fast and start after me.

One cop handcuffed me, then made me wait in the patrol car as the other officer searched my car and pulled out an ounce of clean sifted marijuana seeds.

The ranking officer leaned into the car and asked, What were you going to do with those seeds, Andoe?

Plant them, I said.

Short minutes later I was getting booked in the nearest small town and the arresting patrolman asked the desk sergeant, Is there a charge called "intent to cultivate"?

PINK

December 5 and it was my twentieth birthday.

I was driving my black Chevrolet pickup truck home from Tulsa Junior College out to my new apartment a mile east of my parents' house.

I was thinking how I was going to talk to my dad that night about changing my major from agricultural business to art, seeing there was no way I could get past accounting and I was barely surviving biology.

I wanted to stay in school and that was positive and I could fudge that art thing—no sweat—would be my argument.

I drove east and was about nine miles from home when I saw a dark storm to the south, a smooth upside-down Chinese hat cone shape coming down from the dark jagged clouds.

But it was sunny where I was, on the expressway built high over the Mingo Valley floodplain.

I looked out to the right, over that flat and low part of town and saw, in the sky several miles to the south, a cone of clouds, a breast hanging down that was sleek and smooth compared to the jagged black clouds around it.

Slowly but steadily it lowered as I changed stations on the AM dial looking for weather reports. Nothing.

I watched as it grew into a cylinder that came down and started vacuuming the rooftops of the new neighborhoods a

mile or so south of my folks' house, and about three miles from where I was now, speeding toward it.

Then I saw another coming behind the first, and this one was even closer to me, shaped like a long twisting pink hose in the air, also raking across homes, sucking out insulation.

I was driving fast now and only about a mile away I saw the fat one, in a cloud of big pieces of debris, cross the road a half mile away, on a collision course with my parents' house.

Then I came to my left turn and right above the intersection was that giant pink snake, floating fifty feet above, as tall as the Empire State Building, and it was guarding my turn.

I turned slowly, having to dodge and weave as one-two-three fender benders happened, one after the other, the cars' drivers distracted by the weird pink dick thing undulating in the sky above us.

It was as if nature was mocking the collapse of our social contract.

The light was pink as I turned up my parents' long curving street. It seemed to take forever to drive just two blocks not knowing what I was going to find. I said a prayer out loud, making some kind of conditional promise. And at the same time I thought how at that moment God probably didn't give a shit what anyone might think about his giant skyscraper dragging across commerce and order, precious life and brand-new houses, as if we were ants on a sidewalk.

I quickly pulled into my parents' driveway and the garage door was open. I stopped my truck just as my dad was running

out for his car. He was going to try to outrun the storm, race it to my apartment, to find me.

Pink insulation fell from the sky like snow between my windshield and the open garage door where my startled dad stood, his arms held out like he was balancing on a high wire, a worried frown on his face, squinting, making sure it was me.

PINK, PART 2

That day this stoner from across the street who was too old to be living with his parents was high as usual from a joint he had smoked on his break and was working under a tractor inside a Philips 66 station when somebody yelled "Tornado!" and he walked outside and looked up. There it was, at one o'clock, a two-thousand-foot monster coming his way. In disbelief he watched it plow through the Safeway grocery store that was kitty-corner across the intersection.

He watched as sparks and debris followed by a tall fountain of water sprouted from the collapsing store.

That was when he ran back inside and got back under the tractor where he waited for what seemed like forever. He heard horrible sounds of destruction like a loud grinding train. Second-guessing himself, he climbed out from under the tractor and ran back outside and looked up. The monster was at the curb, about fifty feet away, and it looked like a wall coming at him, too wide to see around. So he ran back inside, pan-

icked, then ran out again, then ran back in. He looked up and saw the sky inside the garage because the roof was being peeled off, right over his head. That was when he decided to run away for good, and he ran back out and got sandblasted. As he turned to run into what was left of the gas station, it was lifting off the ground in a slow rotation around him; that's when he hit the deck.

Luckily the twister was above the ground a little so it only dragged him, in big fast circles, like a scrub brush, over the driveway, almost out to the street, then back and across the wide smooth part to where the gas station just stood and back across the driveway and around and around a few fast times on his belly before it moved on.

After a lot of stitches and bandages for the many cuts and bruises, he lived to smoke weed the next day.

Then there was Milton. He was the proud owner of a brand-new trailer home that had been tied down good because it was sitting on a bald piece of windswept hilltop.

Milton was strapped for cash, but he had managed to scrape up one last fifteen hundred bucks and had planted trees and shrubs along the drive and in front of his house.

About this time the twister was losing some of its strength. But it still managed to suck out all of Milton's new trees and bushes and filler dirt, leaving behind big, clean potholes. They stayed that way for a year till he could afford to refill them.

HEARTBREAK

I was standing in my parents' garage and had just sold my little brother's Yamaha 60 Mini cross motorcycle to a man and his son.

Then my dad pulled up fast, got out of the car, stone-faced, and walked past us through the kitchen door into the house. That wasn't at all like him.

The man and I were squaring up the deal—but I knew something was wrong.

Then my mother ran outside, panicked. She said with desperation, Something is wrong with your father. I think he's having a heart attack.

I went into the house, back to their room down the hall.

He was on his knees, his upper body lying across the bed. He was in so much pain he could hardly speak.

Okay, Dad, I said. Let's go to the hospital.

His face was white but he stood and turned to the mirror. Shaking, he took out his comb and combed back his black hair and looked at me and smiled and said, Let's go.

My dad: forty-one, a big six-foot-three, handsome man and proud of his four sons.

We got into his Oldsmobile and took off for the heart of the city at rush hour.

We got on the expressway and hit bumper-to-bumper traffic right away and he got real bad. He could barely breathe and he slid to the car floor in pain.

We were stuck, just inching along, a long way from help. I

couldn't do a thing but watch him and say, Hang on, Dad, we'll get there. Just hang on. All I could do was keep my hands on the wheel and watch him and keep moving the car along and say over and over, We're going to make it, Dad, just hang on. This lasted forever.

His knees were on the car floor and he was facing backward, his head low in the seat, and he said, I thought only sissies had heart attacks.

We got there and he walked in tall and they led him away.

I cried. I couldn't stop.

In the emergency room was a girl I knew from high school. She worked there as an aide of some sort, and she looked at me, puzzled. Why are you so upset? she said. He's here now. You can stop.

By the next month he had recovered better than expected.

While he was in the hospital I visited him daily. We had nice talks and I told him I loved him every day and we got to see the first pictures from Mars on TV.

I took him a book about World War II prisoner of war escapes, which he loved and read more than once, and an *Esquire* magazine that had the world's greatest BBQ story, which he also read repeatedly and he talked about it more than once; he was hungry.

Then they let him go home sooner than predicted. But he hated recovery and he hated doing nothing and he really hated that much attention. He also hated the diet and not smoking and

just sitting around the house. He loved his family like no one's business but it was crowded with three kids, ages fifteen, nine, and eighteen months, at home. At least I lived downtown.

Being sick is not what he had in mind. He had so many things to do and too many people depended on him, like Christopher, his year-and-a-half-old son.

I was a still a freshman in junior college and was running low on money and was thinking about moving home. I floated the idea for a few days.

But I decided to stay where I was. I called my dad to tell him I was staying put and asked what he knew about renting carpet steam cleaners because the red shag in my garage apartment smelled moldy. He was in a good mood. We had a nice talk.

While I was sleeping that night, for no reason at all, I sprung up in bed, startled. This had never happened to me before.

I lay back and closed my eyes. A minute later the phone rang. I jumped up and grabbed it.

The voice said, It's your mother and I think your dad is dying. She was so scared. Call an ambulance, I'll be right there, I said and hung up. I went to the closet to grab some clothes and she called back and said, He's dead, and she started crying hard.

I fell into the closet, frozen.

Then I got it together and sped home in my black pickup. I ran every light on the way; at three A.M. the streets were mine.

A police car turned its red lights and siren on and chased me for a mile or so through every stoplight I came to. Then I stopped, pulled the brake, jumped out, leaving the door open, my truck idling in the middle of the wide street. All the cop's lights were on me as I yelled at him, waving my arms, pointing toward home, and I started to say, My dad just died and my mother . . . I couldn't finish. I got back in the truck and just sat there and it hit me. I was overcome as I tried to put my truck in gear. The policeman ran up to my window and said, Son, if you don't stop running those red lights your mom will have to bury two of you. Then he said, Follow me.

He must have just heard about it on his radio because he led me home fast with his lights flashing.

And my dad was dead.

It was four A.M. and the house filled up with every relative in Tulsa, some I hadn't seen in years. They went back to his room to look at him. I made them stop and covered him up with a sheet.

Then the ambulance came.

The very second they rolled him outside, a perfect rain shower came, clean out of nowhere, hitting his blanket with a quick fresh flat drumming.

Then so much emptiness.

At eight A.M. I went to pick up my nine-year-old brother, Bill, at his school parking lot, where he'd been dropped off after a Scout camping trip. And said to him, Bill, Dad died last night. And my little brother asked, Is he going to be okay?

No, Bill, he's dead.

I hugged him. He looked up at me, so disappointed, and shook his head. He said, Things like this always happen when I leave.

That day they started to plan the funeral. I was little help. Dad was the one everybody always turned to for things like this. He was the strong one, smart and organized. He was our family's leader and we were lost without him.

The first night in my sleep he came to me and sat on the edge of my bed in my dream. He looked good. He was calm. He had a smile on his face and he told me he was fine and not to worry about him ☺. I'm in a good place, he said. And he gave me some instructions on how to handle Grandma and Mom, things like that. I did everything he said and it worked just like he said, as if he'd been there.

He had spent time in Japan in the navy, and always referred to me as the Number One Son. He let me know how important that job was, how I was his backup.

The next night he came again and gave me more instructions, little details about the funeral to help it go smooth, things that had never even crossed my mind. I listened and followed his instructions and it was a nice, simple funeral, just like he wanted.

(I wrote this three years ago. I still can't type and I really couldn't then. But look at the paragraph above where it has that character after he told me not to worry about him. It's the weirdest thing. I don't know how that little face got there. That never happened to me before or since.

Of course I have seen happy faces and unhappy ones, but not on *my* keyboard. And I've *never* seen one with a straight line. That was the kind of smile he smiled when he meant business. And that was the smile he had on his face that August night in 1976 when he sat on the side of my bed and told me how to make it all work the next day.

I think that's the reason I let this story sit for so long. I felt like he was saying, Don't bother your mother with this.)

OIL

Elvis was one week older than my dad and this bothered him a little.

They came from the same social economic level and latitude.

Same grade, same food, same year, same Captain Marvel comics and Roy Rogers serials.

The same conclusion that they liked Tony Curtis's black pompadour.

Elvis's pompadour was bigger and dyed while Dad's was naturally black and more restrained and timeless. It was just a tiny bit long, by military standards, but still not touching his ears or collar.

A lot around our house was measured by military standards.

Elvis used Royal Crown, a Vaseline-type petroleum product marketed to blacks.

Dad used Vitalis.

My dad always carried a comb and a handkerchief.

His shoes were always polished because the time he spent in the navy had made a huge impression.

He was tall, proud, and honest, and the smartest person anybody knew.

There was a viewing at the funeral parlor after he died.

I drove there alone.

As I pulled into the lot my mother and aunt and uncle and cousins were leaving. They all had a strange lost look that to me said something was wrong, more than grief. They barely waved.

I walked in to find my forty-one-year-old father—tan, handsome, laid out in his favorite sports coat.

But being 1976, they had blow-dried his hair. He'd never bought into that.

And I shit a brick.

I yelled at the three funeral parlor men, Fix his hair right now. This is not the way he wears his hair.

They stared at me. I pointed at him. Fix it, I said again, before one more person shows up, because he wouldn't want to be seen like this.

The youngest mortician left and came back with a comb and sighed like an artist on the wrong side of a critique.

But with just a drop of oil worked in for a second and a quick comb-through—POP—it was perfect again. His jet-black hair had that perfect wave. Just the way he would have wanted.

ART CLUB

I had a relationship with drawing as long as I can remember. It kicked in while I stayed with my grandparents after school, and it spilled over into the margins of my notebook paper in grade school.

I felt it was something of a trick I could do, like wiggling my ears.

I was always surprised when someone enjoyed it. It meant nothing to me, really, but the other side of the coin was that it meant everything. This is very personal inasmuch as I didn't even realize it until recently, because it was too close to see. For me, drawing was like an imaginary friend who wants to play, something that was always right there and made me happy. I could look at the things I felt.

I'm lucky.

Sometimes my grandfather would take my drawings on the road with him and show them around. He once asked me to draw a picture of Little Jack Edwards, another driver, high on bennies, getting out of his truck at the end of a run. I was only five, but I drew a detailed picture of Little Jack looking like a zombie next to his truck, his eyes bugging out.

Another time, when I was about ten, I drew a foreshortened picture of my granddad in the hospital yelling to the nurse through the intercom for more pain pills.

Once, in the fourth grade, I was sitting at the corner table with the other underachievers. It must have been fall because we were using orange tempera and brown and yellow and red

and black. We goofed off all period and then the teacher warned us that we had ten minutes left and were going to be graded on our work. In those last ten minutes I did my painting and the three others'—all in different styles—so we all finished on time and she never knew.

In the tenth grade our high school experimented with the "modular system," which gave students a lot of extra time, too much time in most cases. They hadn't figured out how to keep track of us. I think we were supposed to go to study hall in our spare time. I'm sure somebody did, but it wasn't anyone I knew. So it was a free-for-all for hundreds of kids who only had to sit in class part-time.

I wasn't the only one who got in trouble.

Once Sonny Teagarden organized the first of many midday lid parties during lunch period. We'd all pitch in and buy an ounce of weed (it was Mexican, and it was really three-quarters of an ounce, but it was only twelve bucks), then find somebody whose parents were working so we could go to their house and start rolling and lighting and passing. We did this a lot. The first time at least thirty of us went to the house of some poor kid Sonny had railroaded.

Our goal was to smoke the whole ounce before it was time to go back to class.

Before long it looked like there was a fire inside the new fake colonial tract house. I don't know if we smoked the whole ounce, but there were so many joints being passed around, so much smoke, and so many ripped high school kids when this kid's dad came home by surprise. It must have been funny to

see all those kids spill out of that house and run to their cars. Luckily my first class after lunch was art. My teacher, Linda, was my enabler. She believed in me so she left me alone and let me do what I wanted when I wanted. She even let me come and go and would cover for me when I was too stoned to go to the next class. She was a stoner's dream.

Ten years later I met a guy who told me he'd been in that class, too. I didn't remember him. He said that he and the other boys he sat with across the room would watch me come in day after day, stoned. Everyone would leave me alone, including the teacher, and I kept my head down and would draw and keep drawing until, he said, I would light up and smile like I had been shot up with dope.

I would get a hit.

I would untie the knot.

And it was always personal.

Sure, the other kids and teacher were entertained or impressed by my drawings, but over on my side of town it meant nothing, really. It didn't apply. Men didn't draw.

My mother, who was self-taught, painted very well, and friends and neighbors who saw her work loved it and wanted it. She painted mainly still lifes and landscapes but could do portraits, too. She was a very organic painter and she painted like a momma cat cleans her kittens. I didn't notice it then.

Dad made her frames and gave or sold her paintings to friends and family but as far as I was concerned they might as well have been canning green beans.

In my senior year I was asked to be in the art club that met

after school. I went there one day and looked in the door and there was one guy and ten girls making sand candles. I had no interest in candles or those girls and I for sure didn't want to stay after school.

After high school I took a year off and worked before I enrolled at Tulsa Junior College and majored in agricultural business. But it was boring and I did poorly. So I changed my major to art because I liked school better than working construction. I knew I could fudge the art thing and get my grade point average up and stay in school awhile, which I wanted to do because I had a new girlfriend there.

Then I found out my teacher sold his watercolors for nine hundred dollars apiece.

Nine hundred dollars! Nine hundred bucks was exactly what my pickup truck cost and I thought I could paint as well as he could.

You don't have to be a genius to get with that program.

My teacher was a lot different from me. He was the son of a famous local attorney and a socialite mother who supposedly fished in her mink coat.

He looked like veal to me, all soft and white.

I was twenty and had spent the previous year outside all day, practically every day, from eight A.M. to whenever, working for abusive drunkard bosses. My skin was brown and tough from working in the sun and weekends at the lake, and my teacher was so white. He was only twenty-four, but you would think he was thirty judging by the airs he put on, like the way

he held his cigarette. It reminded me of Lovey and Thurston Howell III on *Gilligan's Island.*

Compared to him I was a pure redneck with a farmer's tan, long damaged sun-bleached hair, and beat-up hands.

I very soon found out this art thing might look like gravy, except who buys it?

Unlike me, my teacher had all these built-in patrons, his parents' society crowd.

But that didn't stop me. I figured out right away that I would just have to do my best, and eventually someone would notice. Or so I hoped. So I worked hard and then I made my first sale to an older woman who was in my class. She offered me one hundred bucks for one of my watercolors.

Shit! That was a full week's pay for me out there.

Then my teacher heard about my sale and caught up with me in the cafeteria and sat down across the table from me and crossed his arms. This guy had never given me the time of day before, but all of a sudden he was on my case. He said, You should have some humility.

What does humility mean? I asked him, because I really didn't know what the word meant. It sounded like humid.

After he explained to me what he meant I don't think I said this but I definitely thought it, If you can do it, so can I.

After that I started enjoying myself, but I was like a puppeteer; it was still like a trick I could do.

I took art history but I didn't get Robert Smithson or Duchamp's ready-mades or Dennis Oppenheim walking across the field making the path or even Pollock.

Then my father's death hit me like a tsunami, a tidal wave. It wiped me clean of any silly thing I was holding on to.

I was blank and raw.

I didn't know anything.

That's when I saw that Marilyn Monroe Tate Gallery poster by Andy Warhol, the one with the yellow hair and the pink face on a turquoise background. I caught the art virus from that. I still have it.

It really is like a club and all the galleries and even the museums are clubhouses that have their own members. For the most part they protect their boundaries and promote their artists or holdings through charming diplomacy and snob appeal. Some are more open than others, but even those may be guarded by somebody whose criteria for membership are about something other than just the work.

For instance, there is a museum in Tulsa, my hometown, that prizes its old masters, but also decided to expand its building and its contemporary collection. My brother Scot had one of my paintings at his hair salon in Tulsa that he wanted to sell, but I suggested we donate it to the museum. It was one of my best, and I thought it would be an act of goodwill, and it would help me establish a presence in Tulsa. By that point, my art had been shown in New York for ten years, and Los Angeles, Chicago, Europe, Asia, and South America.

Well, this fancy curator from the museum in Tulsa came out to Scot's salon to see my painting and I guess she didn't

like the presentation, stepping over toys and piles of hair or the smell of bleach and dye. Is this it? she asked before she passed on our gift.

Meanwhile their collection was full of the work of local artists like my old teacher.

No, they wouldn't hang my work until they had to. And that day came when they hung a traveling group show of paintings that came with a hardback catalog called *Still Life* from the Metropolitan Museum of Art.

I went to see the show and I saw her and she didn't smile.

My guess is that she used the same "reasoning" that holds that anything that happened in America before Columbus is prehistory, the same "logic" that was used to destroy Native Americans, and the same "logic" that left thousands of black people, including old folks and babies, stranded in the sun for days and days when there was dry road stretching all the way from New Orleans to Washington, D.C. It just didn't make sense to the curator of my hometown museum that someone from the east side would have the nerve to think he could hang even one of his pieces in their fancy museum.

I just didn't have any "humid."

BLOWTORCH

We didn't know it yet, but in less than two years James would be my best man—but today I was his.

We had been through so much trouble together, but while he was still getting into scrapes I was away at college trying to stay out of trouble.

James's mother had always blamed me for his problems and still did, even now that I was away at college and he stayed around and was laying brick.

I can hear her saying that he was such a good boy—he was happy and goodnatured but after he failed the seventh grade, well. . . . Before that, she said, he was never any trouble— then I came along.

She always thought I wasn't excited like a kid should be.

I first saw James in the seventh grade, after school one day. He was in a fight, bloody slobber all over his face from his braces that were cutting his lips. It impressed me how he never gave up.

Today he was getting married to a nice, quiet girl from Miami, up in the northeast corner of Oklahoma.

It was one hundred miles from Tulsa, and I rode it all the way with his mom and dad and it was the longest hundred miles of my life.

The sky was overcast and it had been raining all morning.

We met up with James and his bride at a small roadside wedding chapel that was full of faded plastic roses and wobbly taped wedding music.

I stood next to him until it was done and rode with the newlyweds to her mother's house. It was an old wooden house with a fence surrounding it and a beagle in the yard. There were big old elms all around that had roots that looked like

giant worn veins sitting on the surface of the wet, smooth, dark, packed-down earth.

Inside the house the overhead lights were dim and there were at least five little kids running from room to room over the hardwood floor, and some old people sitting facing each other in the living room.

The bride's mother showed up with a large red-and-white bucket of Kentucky Fried Chicken to feed us. She had her hands full and looked overwhelmed but so bittersweet, like she was doing her very best and was hoping this was good enough.

When it was time to go, we all stood out by the cars saying good-bye and James's mother, who was big but looked even bigger with her new beauty-shop hairdo, told me not to ride with the newlyweds because this was their special day and they should be alone.

I looked down at my new cowboy boots and realized that they were too small and hurt.

Then I jumped into James's El Camino and the bride scooted over to the middle between us and we drove off.

Fast, I said.

I didn't have to explain and before his mom was out of sight James had a joint out and lit it with his chrome Zippo's big blue flame turned all the way up.

But it wasn't as big as the one at my back.

KING OF THE COWBOYS

I had never flown before. I was twenty-two and I was going to New York for the first time to take my paintings around (since, as I was an art student, all roads led there).

I was going to stay with my half-uncle who was only four years older than me. He and his wife had been there for three years.

It was the spring break in 1978 when I stepped off the plane with my five rolled-up paintings. My uncle cringed when he saw me. I was a long-haired art student in a beat-up leather jacket and jeans and old white cowboy boots.

He was acting like an asshole, would hardly speak to me, but he had a strong joint and we smoked it as he drove me to his West Village apartment on Hudson and Barrow.

His wife, Janet, was pregnant and she was waiting at home with Regan, their purebred red Irish setter that was long, tall, and slender.

I could feel right away that things were tense inside their big studio apartment.

Soon Janet suggested I take Regan for a walk and check out the neighborhood.

The first person I saw in the elevator was a faint wisp of a man, about sixty, leaning against the wall, looking at the control panel. I stood behind him and saw that he had tiny little dabs of reddish-tan flesh-colored makeup at the corners of his eyes, nowhere else. (Later I asked my uncle why and he said, There's a lot of competition.)

I hit the street. It was late afternoon and I soon realized it was gay Woodstock out there. This was before AIDS and there were hundreds of gay men roving, some crossing busy streets, dodging traffic, carrying bags of food, or walking away from somebody they were holding hands with just to come up and propose something.

I quickly saw how my leather and youth and white boots and elegant dog made me look like bait. That was what had made my uncle cringe.

And that was when I learned that men are men, whether straight or gay, in how they go about pursuing their prey.

The next day I went to MoMA with my rolled-up paintings and left them at the coat check and wandered the place. I was mostly disappointed with what I saw, so I unchecked my paintings and went to the office to donate them. I thought, If *that* shit flies they will love mine.

The black guard at the front desk was amused but told me to send slides.

New York was as strange to me as I was to it.

Outside the museum a young woman who looked Lebanese walked up to me like a stray. She wasn't happy and didn't have anything to say. Then we were walking away from each other and I went to the New School where my uncle worked as a secretary and he suggested I show my paintings to the woman who ran the new museum downstairs.

She didn't smile as I held my painting up in front of her desk, trying to keep the corners of the canvas from curling up, but she was nice enough.

Then I went next door to the Lone Star and had a beer. I met another foreign woman and she was forty and she took me down the street to a big house facing Washington Square Park to see this place she was going to fix up or something—I really couldn't understand what she was saying. But then we got into a taxi and went uptown to one of those glass-walled high-rises on Fifth Avenue where she showed me another place and this one had suede on the ceiling and we just stood there, no chemistry. She acted like she was waiting to be attacked.

I went back to the apartment in the West Village and sat there and smoked pot and listened to my uncle talk about his scams. He told me how he would buy a record and record it, then take a hot needle and make a little spot on it so it skipped. Then he'd take the record back and get a refund. His wife never knew.

He told me about something he did to get a guitar but I tuned that out.

I remember thinking if he worked that hard at a job he would be rich.

He said he wanted to be an actor, but the only acting I had ever seen him do was sit in his car getting high while he waited to move his car after the street sweeper passed by as he listened to the audio of *Taxi Driver* on his tape deck, saying all the lines out loud. He was De Niro.

I saw a lot of weird things on my first trip to New York but what I still think about the most is that old dude in the elevator with the clashing dabs of Max Factor at the corners of his eyes.

For me that's millions of times weirder than dressing in full drag or even being a full-blown post-op transsexual.

I think about how those tiny spots were meant to conceal but looked like neon to me, and how he dreamed they could level the playing field and be the difference between finding true love and not.

I imagined him applying it in poor lighting, and how he must have thought now he'd be mistaken for being much younger.

Back in Tulsa the cowboy Roy Rogers was on Johnny Carson and when Johnny asked Roy how old he was Roy said eighty and then Johnny complimented his honesty.

That's when the king of the cowboys said, I would rather look like a good eighty than a bad seventy.

TOP CHOICE

I got a call early one morning from this pain in the ass Steve dude I saw around art school.

Steve said, Man, we're broke and we don't even have gas, can you take us to the store?

What a chore, I thought as I went to pick up him and his wife at the low-rent married student housing just off campus.

It was cold, dark, and overcast as I waited at the curb in my baby blue pickup. Soon they appeared and they didn't look happy. She never did. She always looked like she was in over her head.

Steve always said he was French but he looked like a musketeer wannabe with long thick curly back hair, and she was small and wispy, almost without pigment; not white but transparent.

I didn't really like them.

But I drove them to the Safeway supermarket outside of town and waited for them in the parking lot. Soon they were back. Steve slammed the truck door and said, Get out of here.

I didn't need to hear that twice.

We started rolling and I asked, Where are the groceries?

Steve turned around and pulled out from under his dark corduroy jacket a monster-sized piece of red meat that strained its cellophane and was overflowing its Styrofoam tray. He smiled at it.

We both looked at her frightened face.

Well? Steve said.

From under her tan corduroy sheepherder jacket (that belonged to him) she pulled a thin slice of pale lame ham wrapped in baggy cellophane and framed by an oversized Styrofoam tray. The price marked on it was well under a dollar.

As if shocked by electricity he spazzed and yelled, You don't steal the shittiest thing!

THE RODEO CAPITAL OF
THE WORLD

The Oklahoma kid was a long way from home on the Fourth of July 1977.

He didn't have to work, it being the birthday of the home of the brave and the land of the free.

So he slept late in the fiberglass shell camper on the back of his baby blue 1970 Chevy short wide pickup truck that was parked on the bank of the Buffalo Bill Cody Reservoir, outside of Cody, Wyoming, the gateway to Yellowstone National Park and hometown of Buffalo Bill Cody.

He was a little hungover when he got out and stood between his truck and the lake. The air was crisp on his bare skin but nothing compared to the jolt he got from the cold water when he jumped in with his Lava soap.

Then he got out and dressed and was good to go.

His hair was wet as he drove through the tunnel, through the mountain, and was still wet when he pulled into the Canyon Cafeteria and had a breakfast of trout with the head still on.

He was feeling good when he drove on into Cody, past the rodeo grounds. They call Cody "The Rodeo Capital of the World" because it has a rodeo every day of the year. Special feature—amateur bull riding. Anybody can step up.

It was close to noon when he landed the prime parking spot right in front of the Buffalo Bill Tavern on Cody's Main Street, which was packed with bumper-to-bumper travel trail-

ers inching their way to Yellowstone Park. It was the world's prettiest day.

The bar was nearly empty. It was old and airy with slow ceiling fans up high and buffalo heads, Indian pictures, all sorts of western stuff on the walls.

He ordered a Ranier beer.

He loved the can, perfect white with red-pink Ranier letters over a picture of the mountain. Made in Olympia, Washington, it said. It was the first of many this day.

It was a loud day of drinking. All day with locals, tourists, and coworkers.

Around five he started running out of gas.

He stumbled out to his truck drunk in the hot afternoon light and sat behind the wheel and passed out.

He sat there with the windows open and his head down, passed out till about ten that night.

When he came to he felt surprisingly good and went back in the bar and ordered another Ranier.

The crowd had thinned out. He sat in the same place at the bar. Just then three young college-age girls came in and sat near him. They were cute enough and the short blonde was easy to talk to.

He told her he was working there this summer and slept in the back of his truck at the lake.

She was from Penn State and she was really agreeable.

It didn't seem to matter to her that he had spent a good part of the day sitting up, passed out cold, behind the wheel in the middle of town, and he was warmed-over drunk.

She had her mind made up and said, Take me to the rodeo.
I want to see you ride a bull.

Anything seemed possible at this point.

They went out to his pickup truck; she liked the whole
deal.

They headed toward the rodeo, listening to the popping
sounds of random fireworks. When they got there the lot was
pretty full, but they found a spot.

They kissed as he was turning off his truck.

After a few minutes of kissing, he asked if she wanted to
see his apartment and she said she did.

They climbed into the back of his truck and did enough to
call it sex.

Then he fell into a deep sleep. She lay there and held him,
this boy she'd only known for an hour or so and listened to the
sound of an occasional firecracker and the rodeo.

KEEPSAKE

It was the end of my summer break from art school. I had
worked for the last three months for a seismograph corpora-
tion in what they call the high deserts of Colorado, Wyoming,
and Montana.

It was hard but fun. We worked way out, at least twelve,
sometimes seventeen hours a day, and often as much as
seventy-five miles off paved roads in Ford four-wheel-drive
pickups. We were trying to survey straight lines across mostly

closed government land looking for oil, land that had very little interaction with humans; its inhabitants were mostly wild horses, antelope, and sage. One day I found a Ford Model-T truck that apparently had fallen into a deep gulley and was hidden there, with a tree growing out of it. It appeared to have been there for a long time. There was a coffee cup sitting on the dash and there was still paper in the glove box. The door of the truck, lying in the dirt, said TRAPPER OF FURS AND PELTS. I took the door. I already had an assortment of antlers, old bottles, and cool rocks in the trunk of my own Delta 88.

I was flying home. I took the back roads, the scenic route. I was in the Oklahoma Panhandle when I stopped at a gas station, the building, the sign, the pumps all dusty and faded. I was filling up when I spotted a hand-painted sign behind the gas station that said MUSEUM OF THE PLAINS—THIS WAY. I paid for the gas and parked, then walked in the direction of the arrow on the sign. I came to a big curved Quonset hut full of old shit: coffins, outdated beauty parlor furniture, old cars, whisky bottles, cow and buffalo skulls, a bunch of human skulls with holes in the top of them, a horse-drawn hearse, rusty bicycles, antique Coke machines—so much stuff I don't even remember. Then came out a tall, old white-haired man wearing what looked like a fishing hat. He showed me around. We talked about his collection. He said that he had lived out there all his life and this was his museum, but the state refused to condone it because the aisles were too narrow, there was no wheelchair access, and not enough bathrooms. Me and the old

man hit it off. I was twenty-two and he was eighty-one, he said. When I asked why those skulls had holes in them he told me that when he was a boy he would find them; Indians had buried their dead sitting up and left the tops of their heads exposed. Vermin would eat through the skull, but by the time he found them they were old and that was a long time ago. I asked him if he wanted to see the stuff I had found that summer.

We walked back to my car and I popped the trunk. His eyes lit up when he saw my door and antlers and things. Sure would like to have that door, he said. No, I like it, I said, and told him how I found it. That just made him want it more. I thought it was funny how such an old man still wanted to collect stuff. So I gave him some antlers. I had plenty and they were mostly pieces anyway. We were leaning over my open trunk when I asked him, Since you're so old, what are you going to do with all this stuff when you die? You got kids or something? He straightened up tall and folded his arms and said in a low, serious voice, I'm going to take it to Mexico. I go, What? What are you going to do with it in Mexico? He says, Yep, I'm gonna go down there and build a cinder-block building, put my things in and lock it up. I said, Why Mexico, why not here?

Then he said, Because Mexico is the only place they let you keep your things after you die.

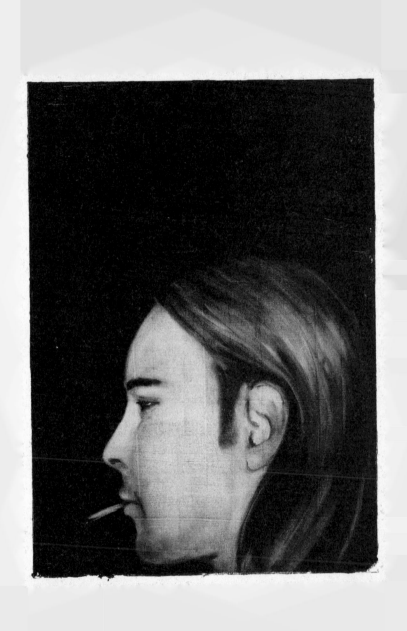

ONE THING

I was in my second year at the University of Oklahoma School of Art when my adviser asked me why I was taking advertising/illustration classes along with my painting studio.

I told him I was hedging my bets. In other words, I might need a job in case the painting thing didn't work out.

He said, You only have time for one thing.

So I took his advice and stiff-armed all my chips onto the painting square.

And kept them there.

It worked.

I felt like I was actualizing my dream; it was like the reward of breaking in new jeans. On the first day of school they were stiff and hot, and at the end they were soft and nice and worn.

I had friends there who were artists where they hailed from, and instead of just rolling along drinking beer and talking about girls we could roll along and drink beer and talk about the different colors in shade and girls.

WHEN THE LAUGHING STOPPED

Randall and I were art students at Oklahoma when we drove to Austin, where he had been an undergrad, to see his girlfriend, Scout, and to do a drug deal. Scout was a quiet, homely girl who had her act together. She had a cute little house that

she kept very clean, and a fridge she kept stocked with beer for Randall for whenever he came to town. She would wait for him. Compared to Scout, Randall and I were pretty wild.

We showed up early that morning at Scout's, already drunk, and then I drank more beer and watched TV while she and Randall had their reunion.

Then we hit the town. First stop was at the baddest-ass tamale stand in Texas, then we went to see Randall's people. We smoked weed and we drank Lone Star and Shiner brand beer. We smoked more weed and drank more beer. Then we smoked some more and drank some more. Then we ate more hot Mexican food and drank. We went to somebody's house and we did some cocaine and we smoked more and drank more. We were doing lines in front of a fifty-pound bale of weed that was stuck in a checkerboard Purina bag, the paper pulled down like a banana peel. Randall bought two pounds. We did line after line of coke, and everyone was talking at once.

We started the next day with hot Mexican enchiladas for breakfast, and beer, and we were pretty drunk by noon. I don't remember that night.

Our last morning there, we were really messed up and laughing out loud and we were drinking Shiner beer and smoking the new weed. Scout was in the bathroom for a long, long time and I had to pee. Keeping up with us did her in, Randall said. The beers were tasting good, and we rolled another joint, but she was still in the bathroom. So I pulled up a dining chair to the kitchen sink and stood up on it and peed.

I was in mid-pee when she came out of the bathroom, scowling and holding her robe shut tight. She looked terrible and was furious. She never looked very happy anyway, but she was really pissed now. She pointed to the back door and shouted, Get out, get out, get out of my house now. I squeezed out a little more and shook it, jumped down, and headed for the door. Randall pleaded with her. But she was really pissed and yelled at him, Get out and don't ever come back.

My last glimpse of her was of her not looking at us and holding her robe shut, frowning, and wiping down the sink.

TURKEY SHOOT

As long as I kept my overhead as low as possible, school life was good, so all I needed to do was paint well.

Even my self-esteem hinged on my last painting.

I was living with a bunch of other college kids in this girl's house. Her dad had bought it for her so she could rent out every corner and every square inch and run it like a business. I am allergic to controlling people who want to control everything like she did, but I deserve some credit because I tried to get along with her and eat crow. I stayed there until I unknowingly did the unthinkable: we had just come in from the store and I stuck a piece of fresh turkey meat into a new jar of mayonnaise and she went nuts, she came unglued, and that caused me to kick a bag of groceries across the kitchen. It burst, and

a big bottle of cooking oil broke, along with some other things.

She ran out all hysterical and a little while later, when I was wiping up my mess, in walked two policemen wearing riot gear helmets and carrying billy clubs, and they looked down at me wiping up the oil and smiled and told me I was going to have to move out by that night.

(Who's the boss?)

ALPHA

I moved to a farmhouse with a revolving assortment of other art students, nine miles away from campus in an old Montgomery Ward catalog house that came in sections seventy years before on a freight train from somewhere up north like Chicago. It sat on ten acres of scruffy overgrown farmland. Surrounding it were a few big trees, some outbuildings, a big propane tank that looked like a green submarine sitting on the grass, and everyone's cars on the sunny side by the kitchen door. We had chickens, rabbits, and goats. The chickens gave up their eggs for breakfast. The goats blessed us with their milk, which I learned to like. And the rabbits mostly fed the possums with themselves. There were at least ten goats, mostly females and babies and one billy goat stud deluxe. The whole lot was a little shy, but tame, and they didn't wander far.

The billy goat wasn't shy at all; in fact he was a little cocky. He and I had a little game. If I could grab his horns

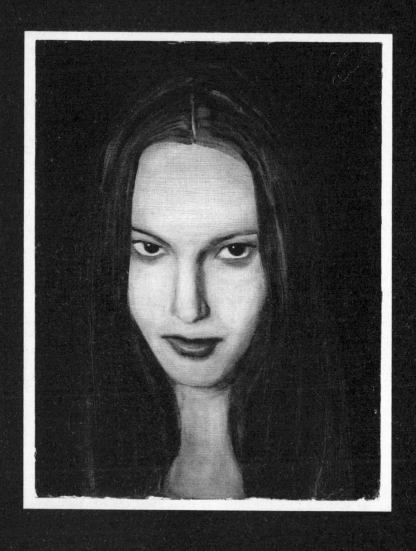

square-on, I could control him. Then it was me against him. *Mano a mano*. But after a while this didn't make him very happy, because every time I walked outside and he saw me he would rear up on his hind legs like a ram and charge full speed, straight at me, from any distance. I would have to run, jump up or into something, or juke him like a football player.

Then one morning he showed me just how much he really, really hated me. I went out the kitchen door to my car and there he stood on the roof of my brown '73 Oldsmobile with all his wives and kids. They had scratched the hell out of my car. My car, no one else's. He stood there proud and stared at me, surrounded by his family on top of my car, showing me who was *mas macho*.

DISCO INFERNO

I was at a party two blocks off campus in a big old house with a big screened-in porch, and it was brimming with clean-cut college kids. I didn't know any of them; my new roommate had brought me. They were all dancing furiously. But I wasn't and I didn't. I just wandered around drinking beer, thinking I really didn't fit in. My roommate and I were standing there talking when he spotted this brunette with a turned-up nose, the darkest eyes ever, skin so fine, like brown olives. I nudged him and said, That's the prettiest girl I have ever seen. She looked at me, then turned back to the bored-looking guy she

was talking at. I stared at her looking so nice in her blue blazer and that brown hair.

It wasn't like me to go out and sell when I wasn't asked, so I wandered back out to the porch and found a chair to sit in. I struck up a conversation with a curious sort of girl. I found her prickliness attractive. I ended up walking her home. Do you want to come in for some tea? she asked. She heated some water. I sat in her ground-floor apartment a few blocks from where we had met, right across from the railroad tracks.

Suddenly the apartment door opened and in walked that prettiest girl I had ever seen. What luck! We were introduced, and then she disappeared into her room. A few minutes later she came out in short shorts and glasses. She looked hot. I dropped her roommate like a hot horseshoe, and then turned on the tractor beam. I was interested and she was interested. She drilled me: Who are you? Where did you come from? Why are you here? You're an artist? A painter? Why that? What do you paint like?

On and on. I loved it. Some push-back. At last someone who just didn't lie there.

The roommate didn't like this and disappeared.

After that night me and the prettiest girl didn't see each other again for a while. Then I ran into her one afternoon walking home. We had a nice conversation and the next time I saw her I asked her out. We ate Mexican. She pointed out how my shirt needed ironing and told me that she was a marketing major and worked in retail. Worked in retail? That was a term I had never heard. She told me how her boss would

sleep with the buyers or the reps or whoever to get ahead. Would you do that? I asked. Are you kidding? she said. Everyone does that if they want to advance. I had never heard of this except on TV or in movies.

She started to look disco to me and I didn't like disco, but she was hot. We started to sleep together; she had the finest body I had ever seen. She was bossy and cold but the sex was great. Also I was proud to have such a beautiful girlfriend. She had a lot of suitors, guys with family money and Trans Ams with big phoenixes on the hood, college boys who wore loafers or boat shoes and no socks, shirts with little polo players on them. Me, on the other hand, I had long hair and slept in a sleeping bag on a bare mattress, and my bedside table was an upside-down box with pictures taped to it. We had great sex.

Then she got pregnant. I pleaded with her not to get an abortion. She said she would, but I could take her there if I wanted to. I do, I said. But one day she went without telling me. I was crushed, this hurt bad. Afterward, even she cried. The world seemed emptier.

We got married after knowing each other for just three months. We really didn't like each other; life was hard, but she was committed, and I stayed. We moved to New York, a big painful adventure. We had a child—a beautiful ten-pound boy by C-section. Not a scratch on him.

Shortly after he was born, I had a dream. A little blond girl, her voice in a dark, cold, empty room said, You're giving that new baby everything and you don't even pray for me.

A FAILED WARNING

I didn't know it at the time, but I was only about three months from getting what I had asked for on our second date (for her to marry me); for now, though this was only our third date, I was in love.

We were back in Tulsa and I took her to a party with my old friends and someone gave us some really strong LSD.

I got so high I lost contact with the outside world and with her.

By the middle of the party I was isolated and way too aware of our incompatibility and differences.

Driving her home at two A.M., I pulled into her neighborhood and we drove past newish ranch-style, colonial, and Tudor middle-class homes with big manicured lawns.

I rolled to a slow stop in the very middle of the dark overly wide empty street. I held on to the steering wheel, looked around us, and asked her, Why do they do that?

Do what?

Why do they cut their hedges like that?

That's when she saw, even in the dark, that every bush in sight was cut into a shape—a cube, a cylinder, a cone, a sphere. Also animal shapes, like an elephant, a rabbit, a squirrel, and a deer.

I was paralyzed.

I couldn't get past them.

She took hold of my chin and brought my face close to hers and said, It's okay.

THE FIRST STAND

It was hot and insane and it just took an instant.

It happened on our second date in that state of crazy when I did what couldn't be undone.

It's something you never, ever do unless you mean it really and truly because it's like joking with the guy at the metal detector.

And it is the very thing that will affect you for the rest of your life.

I asked her to marry me and she said yes and held me to it and I am still paying for it.

I remember at the time realizing the mistake I'd made and thinking if I pretended I didn't ask in the first place she would forget about it and it would just wilt and fall off.

But no. She had me by the scruff of the neck.

Then one day I suggested nicely, What if we just live together?

My leash tightened.

By muttering those four little words (will you marry me?) in just that combination I unlocked a safe full of responsibility.

I was now officially in charge of her future and self-esteem, her entertainment, her status, and her happiness, and in general I was now in charge of making her dreams come true, so how dare I even think about neglecting them? Besides, she said, my family knows we slept together.

The good thing was that she looked like a hot fashion store clerk. But we didn't get along great.

I said, Common sense would say that we shouldn't get married, that we should just date.

That was when she said, Too bad. I already told my mother and she has told everybody.

So three months after our second date we had our wedding day.

It was the middle of summer and it was hot as hell and I was depressed and drove around aimlessly all day long before I went to my mother's house to get dressed thirty minutes before my vows and Mom could see how depressed I was and she cried.

I said, Oh, Mom, I can always get a divorce.

That just made her cry harder.

The collar of the shirt I planned to wear wouldn't fit over my tie so she raced to Anthony's, the cheapest sundries store around, because it was the only thing close. She brought back two short-sleeve shirts that were made from petroleum (that's dinosaurs and prehistoric forest)—there is nothing more authentic than poly. I have no doubt that my wedding shirt still exists in a layer of landfill someplace and will remain unchanged till long after I disappear.

I drove to the church with sharp fold marks in my new beige shirt and I hoped no one would show up.

I had wanted to do it at the justice of the peace, because I think the effort should equal the content. But then her dad suddenly woke up to the fact that he had a daughter, one he didn't know, and she was getting married. So he did something he had never thought of before. He looked for his handbook

that was still unopened from the baby shower twenty-three years before and caught up with the plot at the end, in the chapter titled "Daughter's Wedding," which starts something like, "Old man, you're almost done."

He took his cue and stood up and said his line promptly: Can't I at least give you away?

How could you say no to someone who had slept through his whole show?

You have to let him do his last scene.

So I had agreed to a "small" wedding in her church.

"Keep it small" was my mostly ignored motto.

I was late when I walked into the church on the good side of the tracks. It had been closed up all day and was hot as hell inside because they opened it only thirty minutes before and it hadn't had nearly enough time to cool.

It was nearly one hundred degrees in there as I walked up the aisle and saw James standing there in corduroys, cowboy boots, and a sweat-stained striped T-shirt.

And he smiled at me like "You dumb shit."

I stepped up onto the altar.

I turned and saw that her side of the church was full and my side had only twenty or so people.

On her side everyone was frowning.

On my side they smiled.

Her side thought she was marrying down.

Mine, up.

The wedding music intensified, then here she came. She had had her tail tied to her mother all day and had been thrown

over a clothesline at the beauty shop and she was looking all stressed out like she was tired and had just drunk Pepsi and burnt coffee all day, all day as she fought with her mother about her mother's dashed expectations.

Now as we stood with our backs to our clans and faced the music, I looked at her and I saw she had baby's breath in her hair, but then she looked at me and she gave me a look like a dog that's fixing to bite my face.

We said our vows in front of the horny preacher.

Then her friend who we had thought could be the photographer was lame as shit because he was distracted because he was going to lose his gay cherry that night and didn't know what he was doing anyhow. But because he had matted black-and-white photos at his house we thought he could do it.

At the after party at her folks' house, drinking was as welcome as Jesus.

And her dad who always tried hiding his drinking wanted to make sure there was enough for everyone and bought cases and cases of the cheapest champagne in history that was mostly warm.

Relieved, I drank, and kept topping James off.

He didn't have to be on top of his game, though, to see the icy reception her family gave him and his wife.

So I stood in the crowded living room away from her side and I told James, who was sitting on the piano bench with his wife, I'm going to set 'em up and you knock 'em down.

Pitch till you win, I told him.

I kept pouring and he got drunk fast; he downed about

fifteen glasses in a row before he didn't hold up the flute for more.

Besides all that, I was sneaking champagne to my new wife's retarded great-uncle who wasn't supposed to drink at all. Whenever his sister saw him holding a glass she took it away from him, but I'd just give him another.

He melted my heart as he sat there by himself in his Old South rumpled summer-weight suit and suspenders, and he would point at my bottle and say like a southern gent, You still drinking?

I don't remember the end and I don't remember my bride carrying me over the threshold.

But I do recall how my body rejected that shitty champagne from both ends as I drove the porcelain bus later that night.

By the next afternoon my hangover was fading and she made out a long list and sent me to the supermarket where I either lost it or disregarded it. Nevertheless, I came back with even better things, but she found them so offensive I thought she was kidding.

She was the kind of mad that you get when someone leaves the gate open and your pet gets run over and they try to turn it back on you.

But not for bringing home the wrong groceries on your first full day of marriage.

My worst nightmare came true that very first day, so I got drunk again and finally (a little late) stood up for myself but pain was in the mail.

We spent the next few days in shock inside in the air-conditioning before we decided to go swimming on campus.

Then there we were surrounded by a thousand hormonal college kids in the sunny Olympic proportions of the pool and I pulled my new beautiful bride with cleavage so deep over to me and she pushed me back and scolded me sternly saying, Don't be so demonstrative toward me.

It crossed my mind to swim down to the drain and hold on and breathe in deep.

MORE SONGS ABOUT BUILDINGS AND FOOD

My brother was a newlywed and I was, too. Everyone was a student; both of our wives had jobs, but we didn't. One Sunday I was at my in-laws' (still without a job) having dinner and I told them a funny story about how my brother went to look for a job only to find his wife a better one. They sat there stiff. That was it. You could've heard a mouse pissing on cotton. When that story was told at my mother's, it brought down the house.

Her drunk boyfriend complimented her saying, Those boys of yours sure know how to marry.

MAKE ME ONE WITH EVERYTHING

Me and my newish bride had one thing that had just enough jam to hold us together, and that was that we both wanted to move to New York City.

We first visited there the summer before the summer we stayed for good. The Lincoln Tunnel spit our red VW Rabbit into Times Square and was bullied by yellow taxis.

We stayed with Randall, a friend of mine from school, and it took three days of drinking with him before we realized we weren't seeing another of the Big City sights other than the bar he called his office, and so took off by ourselves on foot with our map into the August heat wave.

We walked uptown through SoHo and the Village, then up to Macy's because I hadn't packed any pants and I needed a change.

It was so hot. I picked out some large, bright blue draw-string pants—like floor-length gym shorts—that had a bright white cotton drawstring that tied and hung down in the front. They were stiff and ironed flat and folded; they just needed a wash and they'd be ready to wear. But I needed them now, so I paid for them and put them on in the dressing room and wore them out.

When I stepped out into the heat on Eighth Avenue, I looked down at my new pants and the big stiff shiny starched folds looked like waves that I wished weren't there. Instantly I had buyer's remorse but thought, Shit, this is New York City

and these people got bigger fish to fry than caring about whether my pants are happening or not.

I could never have worn these back home because someone would throw something at me from a moving car.

We started walking uptown and with each step I felt freer, less restricted in every sense.

In my head I was thinking how well I fit in here, in Manhattan, and how these were my type of people.

I was practically having a cinematic moment as we crossed Forty-second Street into Times Square, thinking how I could see myself living here, just letting my freak flag fly, as we joined the crowd under the one o'clock bright hot August sun and the big signs, and thinking how I was now in the middle of the world and how I had arrived, wearing my stupid-looking blue pants, and how even that was proof that my acceptance here was unconditional. That was when I came upon this shirtless black dude walking toward me on the sidewalk, with a silk scarf around his head and a big gold chain and new white sneakers, and his head started moving when he saw me because he couldn't wait to say . . .

Man, those pants look like shit.

THE TOPS

The first time I stayed at my in-laws' after our wedding was difficult for everyone involved.

First off, her mother hated my guts and her dad wasn't supposed to like me, either.

We bedded down in the upstairs spare room on a bed that had no identity; it was just a rectangle of mush covered with sheets dirty from dogs and kids playing and jumping on it, and the room was hot. They had plenty of money but were cheap-cheap-cheap and didn't turn on the AC even though it was ninety degrees at midnight.

I woke up about two hours after I fell into a deep, exhausted sleep. I found pools of sweat in my ears. And the sound of a vacuum that never stopped.

My mother-in-law felt dirty with me sleeping there with her daughter so she cleaned all night.

And she cleaned noisily.

Since it was summer, and there was a water shortage, it was recommended that lawns be watered at night. So around three A.M. my mother-in-law yelled up the stairs: Mel, Mel, Mel! Get up and water the lawn. Poor guy had to work in the morning, not to mention there were six other people in the house, who were asleep until she woke us up, all because her daughter was sleeping with me on that crummy bed.

It was three A.M. and I heard my new father-in-law grumbling as he walked past our door, *boom-boom-booming* down the stairs, giving the whole house the harmonics of someone walking over the back of a giant hollow-body guitar in hard shoes. All because they'd used the cheapest lumber in order to be thrifty.

He watered and she cleaned and I finally fell back to sleep only to wake up minutes later when she yelled up the stairs again, this time to her youngest son to come fold his newspapers for his morning paper route.

Then it was the twelve-year-old's turn to *boom-boom-boom* down the stairs, yelling abuse at his parents, which they always seemed to enjoy. It quieted down again as she helped him fold the papers to be delivered as he rode his bike around their south Tulsa suburban neighborhood.

I drifted to sleep again, only to be jarred awake by that brat crying and stomping his feet because he was frustrated because he was a brat and his bicycle fell over and all the papers had spilled out of his basket.

I hated being there.

At breakfast I encouraged my new bride to ask her mother why she didn't get a new mattress, noting that was no there there for the one we had slept on.

My mother-in-law said, That's a good mattress. We paid a hundred for it—twenty-five years ago.

Other times we would sleep in the downstairs bedroom next to the den. It was quieter and cooler but it was next to the living room. My in-laws got up with the chickens and I would lie in bed at five or six in the morning and listen to her tear me apart to her husband. She rewarded her husband with a light-hearted cackle for any scrap of my flesh he could deliver, or evidence of how stupid or worthless I was.

By the way, my wife had said early on, you remind me of my dad.

My mother-in-law was these two things: the meanest person I have ever known, and the one who has hated me the most.

She took every shot I gave her.

Most of the time she acted like she also hated her daughter, who bent over backward trying to please her.

At our first Thanksgiving dinner at my in-laws' her mother was every kind of aggressive. So here was my new wife—she helped with the dinner, set the table, sat up straight, used the right fork, and wore lace, and the only thing that came from her mother was pure hostility.

All the adults were sitting around the table when their twelve-year-old son arrived shirtless and wearing only his underwear, yelling at his mother to get him a Popsicle and that she knows he doesn't like turkey. And that Popsicle was promptly peeled and handed to him with a napkin when that brat yelled at her, I WANT A GREEN ONE, STUPID. HOW MANY TIMES DO I HAVE TO TELL YOU ONLY GREEN? DON'T EVEN BUY THE OTHER COLORS.

He sat across from his uncle and aunt and next to his dad where he was petted like a prize Labrador as he curled up sideways in his chair, wearing only his underwear.

His dad said, Show your aunt and uncle your muscles.

The brat just ignored his father, who then said, He's the fastest swimmer on his team.

Nothing.

Then my father-in-law said something about wrestling, telling everyone that his son was in really good shape.

I saw no point in suffering this just so my new wife could save face.

I still don't.

By the way, her little brother turned out to be a pretty good guy.

My clan was on the other side of town.

So after dinner we left.

And when we ventured over to my mother's house, it was like a twenty-four-hour party compared to my new wife's parents' home. My new bride came along to monitor me, to make sure my joy didn't get out of hand because her biggest fear was that I might be happy without her, and she would lose control of me, and I might get some idea that she didn't okay.

Like mother, like daughter: if you showed up on a pink cloud, she would take her little silver needle out of its sheath and puncture it.

They were masters at finding out what it was that made you so happy, then try to convince you that you were wrong.

For instance, she would interject if I dared to exaggerate my importance or power, and quickly remind my family who made the most money.

One time, without her approval, I impulsively bought a sweatshirt that advertised my school, Oklahoma University. She ripped it out of my hands in front of everyone and returned it.

But it was on sale, I said.

I think that, like a herding dog, she thought her job was to cut me out and away from my pack so I would focus only on her so her own family could take root. Maybe she thought if I looked away, my heart (or dick) would, too, and that would weaken her security.

So she stood guard.

She once said, Take your sunglasses off so I can tell what you are thinking.

Over time I learned how to manage this situation at the in-laws' better. Like going to bed at nine to avoid face time with them.

She said that ignoring my mother-in-law was the worst thing I could do.

I asked, Worse than yelling at her?

And she said, Yes.

And over time I started noticing patterns in her mother's cries for attention. I was horrified by the poor behavior around the Christmas tree that first Christmas. They actually yelled at each other for getting the wrong or shitty present. That first year my wife got something that offended her—something made of polyester—and she screamed at her mother and I saw her mother's reaction, like "Oh, naughty me." But then she smirked, enjoying the rage coming her way.

So the next Christmas I said, This time when you open "that" gift, don't take the bait. Just give her a hug and thank her and move on.

So here came the big box from her mother that my wife opened. She pulled out a heavy brown bedspread made of fake fur with a big tiger face on it and it was 100 percent polyester. She calmly folded the spread and set it down, leaned over and hugged her mother, and said, Thank you, Mother, it was such a nice thought. Then my mother-in-law stood up and went into the kitchen and cried.

Not out of happiness.

STAIRWAY TO HEAVEN

I was twenty-six and it was the day before I moved to New York. My grandmother, the Christian fundamentalist, was deeply concerned that I had not been baptized and since I was going to New York she insisted that I do so because she didn't want me to get there and be killed and not be able to get into heaven. So I agreed to do it the next morning, a Wednesday. I stayed up all that Tuesday night partying with my friends, drinking, smoking weed, and snorting cocaine.

I went straight from my friend's house to the church where there was a small congregation of a dozen or so old ladies and a preacher and my mother and my grandmother there to greet me. I had disheveled long hair and the makings of a beard and was wearing the same clothes from the night before. The preacher took me up to this pool behind his pulpit and I changed into an old pair of slacks and an old white shirt they kept there for just such an occasion. I stepped down into the pool of water with the preacher, in clear view of all the old women and he asked me, Do you believe that Jesus was God's only son, or something like that. I was qualified to answer that question as I was of the age of reason. I was standing there very, very hungover and this tall gray-haired elderly man held a handkerchief over my nose and immersed me in the baptismal pool. When I came up out of the water and started to step up the three steps and out of the pool, I felt amazing, rested, and refreshed. Out of the corner of my eye, the baptismal pool seemed to have a film of oily scum floating on the top of it.

And that is what I told the preacher. Later that night he gave a sermon on me saying that.

I changed back into my clothes and my long hair was wet as I walked out to a reception line made up of the old blue-haired ladies whose husbands were long dead. They were all crying and shaking my hand and kissing me on my cheeks. They had the enthusiasm of groupies. I got to the end of the line and there was my mother. And I said, Mom, why are they crying? She said, It's because they think you look like Jesus.

FOR THE ASKING

I could have painted the Mona Lisa in Oklahoma and no one would have cared.

But living in New York took some adjusting to. My friend Randall from art school had moved to Manhattan the year before and built out a cheap raw space with a friend he knew from Texas.

Randall's friend already had a bad drug problem, and then it turned really bad, and he nearly died from an overdose. He promised his family he would go to rehab, and he had to give up his part of the loft.

So Randall called me as I lay dying on the vine in Oklahoma. I was out of school and my new wife had a nine-to-five job. I was working as a substitute teacher for the Norman, Oklahoma, public school system and was developing my

portfolio of lawns that I mowed with the new John Deere lawn mower the in-laws had given us as a wedding gift.

When Randall said I could have his roommate's space for a five-thousand-dollar fixture fee that I didn't have, I made a deal with him and sent about half and agreed to pay the rest in monthly installments.

I packed a trunk and flew there; my new bride would meet me in New York in a month. I arrived at my new place only to find Randall's roommate saying through the closed door that he had never got the money, which meant I was being duped.

So here I was in New York after taking everything I had and paying for an apartment just to find myself at the door a long way from Oklahoma and unable to get in because this guy was trying to get more money out of me.

So I called my wife; she was the one who kept track of the details. Then I calmly reminded him that it had been a cashier's check and it had been cashed; he said he would move out.

In other words, he had spent it on drugs and was hoping for more.

MARLBORO LIGHTS

In 1982 when I moved to New York and down to Murray Street, I met a lot more young artists from Texas, Connecticut, and Wisconsin than I did from New York. Just like in grad school the place was chock-full of well-financed, white-bread young

men and women who slept late and called themselves artists but had nothing going on because they needed even more money or something was wrong with their studio, like they needed a bigger one, or what they really needed was a studio with a skylight because they could only paint in daylight but the way it was now was too dark in the little corner of their loft that they had allocated to paint in, and they needed a big studio anyway because they only wanted to paint the big paintings they couldn't afford to make without more money and space.

There were always millions of reasons not to paint and it looked like some of them felt they didn't have to anyway, because it was really just a matter of meeting the right person and then getting hooked up with the right gallery and that way they would have some incentive. They'd have a stipend and they would hire some assistants because they were that good, and this is what they deserved. Besides, they had plenty of paintings already and the idea of working hard and making even more paintings was so stupid and old-fashioned, like something their father would say.

I didn't know where the line formed for this mind-set; maybe their mothers had done too good a job.

This idea that you were somehow entitled to what you wanted just because you were you was completely new to me.

I'm sure that they all got read to a lot when they were little and even had lessons from good art teachers in summer art programs under the shade of wide old trees in view of something grand like a Roman aqueduct. Or maybe their parents

collected art from the city and took them to see the shows and were entertained by artists in their studios. And maybe they helped their parents pick out just the right picture and they watched as their parents bought it, or as kids they appreciated someone like Forrest Bess or Al Taylor and the art dealer looked down and smiled on them and told them in front of the proud parents, You deserve this here art career, and the kid believed him.

Some of them resented me because I painted so much and some called me a workaholic.

I didn't know how to go about getting what I wanted besides working for it and not stopping working for it until I got it. Besides, I liked to paint.

I wasn't going to suck dicks at parties or even kiss the asses of people I didn't like so they would like me. That was not going to happen. But this is not a recipe for success.

My finishing school was pushing wheelbarrows in the heat and carrying ninety-pound bags of cement.

So I was lucky enough to know that my strength lay in my hands, not in my social skills. My only choice was to make my next painting better than the last. They had to succeed on their own no matter what I did or didn't do socially.

I wanted to paint the way a smoker wants a cigarette. I never heard a smoker say, Oh, I really want to smoke but do I have to go all the way outside just to buy a pack?

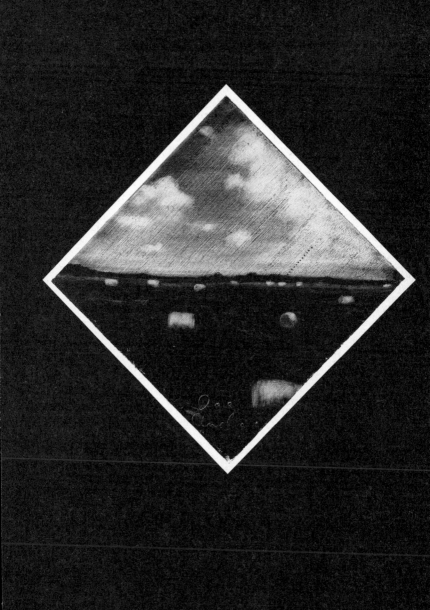

THE ROSE BOWL

"My water broke!" she said.

I jerked up the two steps of our slightly elevated make-shift loft bathroom to find muddy water on the plywood bathroom floor.

Shit, I don't have any cash, I say.

It's not happening right this second so go to the ATM, is probably what she said.

I ran three blocks to the World Trade Center and the nearest ATM. I ran back and she was packed and we headed out to Church Street to hail a cab.

I remembered someone telling me that taxis don't like to pick up pregnant women so I hid her in a phone booth.

Taxi came and we were off.

She went in for a C-section because she was only five feet tall and was carrying a huge baby.

C-section is definitely the way to go. Wham bam—they brought me out a ten-pound, nine-ounce baby boy, and the nurse said he was the prettiest baby she'd ever seen.

YES!

TOUCHDOWN!

Our half of the loft was precarious because we were there illegally and the landlords didn't know we were living there.

The whole real estate scene was booming overnight, and what the year before had been a glut now was tight and prices had doubled.

And we had no lease.

All we had was the key to the door and Randall's knowledge that we paid to live there. Randall held the lease to this raw space that had been a printing press for almost one hundred years until it closed, like so many other old businesses in lower Manhattan, right before the artists came.

Randall had this power over us.

And like so many assholes who have leverage he loved to remind us of it. Any time we brought home something new, like this baby, he would say, You'd better hope the landlord doesn't find out that you live here.

I felt like a boat person.

HUMPTY DUMPTY'S TIPPING POINT

Being a mother is tough going—I know, I done it.

It's a whole lot tougher than it looks; it's sort of like you are a goalie on a twenty-four-hour, seven-day-a-week soccer game that never ends and it's really slow and the shots will come just when you think they will never come again, and no one ever sees your save.

That once a year score on you can cost you not only the game and a career but the Hall of Fame.

And because it doesn't look like you're doing shit, people treat you like you don't work.

Even your spouse can come home and disregard the fact that you kept the kid from falling out of the window or running

into the busy street or eating rat poison at the park, or you stood in line with a fidgety baby and made that payment so that thing didn't get turned off.

So you try to do extra because if you don't, you're never going to get any respect.

Like the time you looked up that special recipe your spouse liked at those people's house and then you went to that fancy store that's all the way over there and brought all that stuff home while you were caring for the baby, and you cooked it, squeezing the lemons and everything.

Your spouse comes home late and grumbles about how messy the house looks and then frowns when she looks at the fancy chicken and asks if it's overcooked. Then she denounces the whole meal because she found lemon seeds.

Then there are the times your in-laws treated you like you were second class because you don't bring home money the way their baby does.

And there's nothing like running into old friends, and after they give you updates on their big adventures, your spouse is eager to tell them "that joke": she wants to come back in the next life as you because all you do is lounge around all day with a baby.

That's the way it was.

Then there was a defining moment. The baby was getting bigger and I was getting better at my job—and I knew it.

One day I cooked a meal with no seeds. I had cleaned, and even waxed, the floor. After I took the baby to the doctor and waited a long time and got his ears looked at and learned

that because the new pink medicine worked better than the last stuff, his ears were nearly cleared up, I was real happy because I had hated giving him antibiotics for so long. When I got home I picked up the newspapers from the weekend and the ones from last week and made a tall neat stack on the chair by the door. I put the baby down, and that's when I started dinner. It was so quiet and clean and calm.

It was already dark when she came home to the smell of dinner, to the sound of the rattling lids and the sight of the shiny waxed floor and her baby who felt better than he had in weeks and who was really happy to see her.

Standing inside the doorway she pointed to the tall neat stack of *New York Times*.

And she said, in a loud harsh tone: What do you think you are doing mixing the papers I have read with all the papers I have not?

She stood glaring with her hands on her hips as I just slumped and nodded and said I'm so sorry and walked away slowly with my head down like a beaten dog over to the neat stack and picked them up and walked to the window and flung them out of our twelfth-floor apartment into space.

With first a rustling sound, before they all separated silently and slowly floated to the street, elegantly.

She stormed out.

I sat down with the baby in the high chair to eat our nice dinner. No seeds.

She came back twenty-five minutes later with a bundle so large she couldn't put her arms around it.

Ignoring dinner she sat with her back to us on the floor, for hours, in her business suit, and reconstructed the papers perfectly. It didn't matter if she would ever read them or not.

KING ME

Randall called from Houston to tell me that his drinking buddy, Miriam, was in his apartment next door to me in New York and was in trouble. This other drunk, Jim King, was supposedly trying to rape her.

That slut is asking for it, I said.

Yeah, but he won't leave her alone. Just go over there and throw him out, Randall pleaded.

Fuck, Randall, I said. I hung up the phone and picked up a thirty-six-inch heavy-duty canvas stretcher bar and went next door.

Miriam and Jim both looked drunk.

Miriam said, Joe, tell Jim to leave.

I said, Randall called from Houston and asked me to come over here to ask you to leave, Jim. So please leave.

Jim King was funny-looking, kind of like Groucho Marx without the mustache.

He was a drunk and could speak Russian. He worked nearby on Wall Street and hung out with Randall and Miriam at McGovern's bar. He had a good job, so she let him buy her drinks.

Now he wanted sex.

So here I came to the rescue.

You want to make me? Jim asked as he started walking fast toward me. I swung the heavy-duty pine Utrecht stretcher bar hard across Jim's left shoulder. Thud. That knocked Jim to his knees, stunned.

I backed up and yelled, Get out, Jim!

Jim stood and then charged me like a bull.

I swung down hard again. I hit a line drive across Jim's left temple. *Splat!* A sick sound.

It spun Jim all the way around and straightened him up like a dancer before he landed flat on his back making a loud, deep thump.

Before he could move I laid the bar across Jim's neck and put my knees on it and pressed down.

All I needed to do was shift my weight on the bar and it would be sayonara Jim King.

Jim's face was red and he was choking.

I told Miriam to open the door as I was scooting Jim out inch by inch on his back. I was looking right into Jim's red face. He stunk. I was way closer to this guy than I ever wanted to be.

I saw the big bloody welt on the side of his face and smelled his bad smell and I told Miriam to take Jim's briefcase and trench coat and throw them out the twelfth-story window. When she did, he struggled, so I pressed down with more weight and cut off his air. When Jim stopped struggling, I let up just a little. He could breathe again, and then he averted his eyes from mine to my shoulders and then back to my eyes

and said in a raspy whisper, You're really not that strong, Andoe.

APPRECIATION AT THE DOOR

Me and Jane and our baby were living in a loft with Randall. We were on both sides of thirty, Randall being on the later side.

After three years of sharing this place (even though we had separate entrances and a door and wall in between), I had had it. You see, Randall was a complete alcoholic; his cigarettes and drinks were on the same schedule. And he smoked more than two packs a day. He slept with a drink next to his bed. Then there was pot. He sold pounds, held pounds, smoked continually. There were as many pot roaches in his loft as the New York kind. He also bought scales to weigh pot. To buy these kinds of scales you have to give up your identity to the government. He did this because this guy in Connecticut asked him to. In return, the Connecticut guy would be very liberal with Randall, hence the pounds.

Randall was from Texas; all you had to do was ask him and he'd tell you. He had also taken karate at some point in the past. Kung fu snake style; he would give a demo any time of day. He would often show me how he would kick my ass when the time came. I took note.

Randall was weak with booze; the smell around him was a mixture of gin, pot, BO, cigarettes, beer, and oil paint. A

sweet, sickly mix. He tortured me by constantly reminding me how unstable and illegal my living situation was. My side of the loft had a baby bed, clean dishes, yellow curtains, and sometimes, flowers.

Randall's side of the loft was sticky. His dishes had mold. Stale, half-eaten catsup sandwiches and a full-length mirror that made everyone look a lot taller and prettier. There was no door on the toilet, and the mirror was rigged to reflect the toilet from the kitchen. The bath was out in the open. Randall somehow got intimacy mixed up with private bathroom and toilet business. I wanted out. I didn't care if I had cheap rent. I didn't like my cold wife much, but I loved my baby and liked having a family. I wanted a safer home for them. I did get a small art studio in another building. I didn't go there till after the dinner dishes were done. I took care of my kid during the day, and at eight or nine o'clock at night I would take off to go paint.

Randall had always thought that my wife was a dish. Maybe you got the best piece of ass, Randall would say, and would take the opportunity to lose his keys when I was gone. Same story each time. Jane, this is Randall, I'm drunk and I lost my keys, can you let me in? This made her uncomfortable. He never lost his keys when I was at home. I told Jane not to let him in. Fuck him, I said. So next time it was, Sorry Randall, I'm not coming down. Randall found his keys and shortly was at the door that separated the apartments, calling her a cunt, a bitch, and a whore. I came home a few hours later and was told this. I walked straight to Randall's side. Randall

was naked and had some coke whore with him. You better leave, Randall warned me. I walked slowly toward him. Randall, I said, you are a lush and a phony. Then Randall started his naked kung fu show complete with sideways walking, fancy hand movements, and not looking me straight in the eye to psych me out. I lunged to grab him by his long hair and slammed him facedown on the dirty floor. Sitting on his back, I yanked Randall's head up by his hair and pounded the right side of his face. I pulled Randall's hair hard and asked a question: Are you gonna whip my ass now, Randall? Pop, to the side of his face again. Then I bounced his face on the floor, pulling it back up hard. Are you gonna use karate on me, Randall? Pop, pop, pop to the face. I slammed his face down again, then the coke whore jumped over Randall's head, screaming and naked. I couldn't reach his face so I pounded him in the kidneys. Angrily, I tried to hit his face again but hit the floor instead. This broke my hand. I left, going back to my side through the door.

That door separated heaven from hell. All kinds of shit hit that door. Words, objects, threats. Then the police came. They could see the bitter contrast; they could see the bottles, the crack vials, and smell the stench. They saw my baby and his toys. But I had walked into Randall's home and beaten him up, so they were going to arrest me. As the police clamped on the cuffs I said, so Randall could hear through the open door, Hey, Randall, when I get downtown I'm going to tell them about how you buy scales for that guy in Connecticut. And how he fronts you pounds.

The police were starting out the door with me when Randall had a sudden change of heart. He told the police that he wouldn't press charges after all. The police let me off. My broken hand was swelling up. It was quiet now and I figured it was safe for me to go and get it fixed. In the morning I came home proudly with a cast and Jane greeted me at the door with, I wish you hadn't done that.

(Sometimes I felt like I came from an island with no predator. Like a bird who thinks it can just walk around.)

GATEWAY TO THE WEST

In 1976 *The Book of Lists* said that Jersey City was the worst place in America to live.

In the '80s, Jersey City real estate bubbled up and we bought right when it was at the peak. Well, it might have been falling a bit, but no, I think it was at that moment—right then, as it held and floated before it fell.

To get there, you took the subway to the PATH train that left the World Trade Center, going two stops. Then you got out and walked your legs off.

Jersey City brought out the worst in me. I was a real asshole there. It sucked and so did I.

I was a shitty husband.

I was not friendly to our neighbors and I had nothing but contempt for our community.

I drank heavily and snuck around and did drugs.

Moving to New York hadn't worked out and to me, moving to Jersey City was my polished turd trophy, my symbol of my failure.

They say happiness comes from within but that wasn't the case for me in Jersey City. I was unhappy moving there and only happy the day I left.

Something was wrong there.

I had lots and lots of hangovers and domestic struggles and real-estate problems.

On the other hand, my wife was determined to make it work. She joined the church and made friends.

And the first one was a doozy.

My wife's criterion for friendship was different from mine. Her new friend was Carla and she was so medicated she seemed to live in a twilight state.

My wife would prop Carla's six-foot thirty-year-old skeleton in the kitchen chair, lean her into the corner, and place a mug of coffee in her hand, and then the wife would ad-lib her diatribe on any old theme. I don't even know if Carla was awake half the time because of her silence and her dark glasses.

But I had John, this dweeb from Iowa, as my friend. Who smoked weed and drank with me.

There wasn't a bitter bone in his body. He was totally positive even when he was drunk off his ass in the middle of the day while his wife worked in the city, down on Wall Street. He was the only friend I had out there.

One of the only things I found fascinating about John was

that there were three years of his life that were unaccounted for, which he had lost in his twenties out in Bay Ridge, Brooklyn, where he moved to from Iowa in an extremely unfocused state after he had changed his mind about going into the priesthood. He just couldn't remember what had happened those three years.

I don't know why I found that so interesting during our own wasted afternoons when we smoked weed.

I lost fifteen minutes in Jersey City one morning.

Every day I woke up like clockwork at 6:59 A.M. and hit the alarm before it went off at seven. I bounced upstairs and turned on the news and got the paper and made coffee. No matter what time I went to bed this is how I started my day, rain or shine. I was on kid schedule.

This morning I hit the alarm like usual but by the time I got upstairs it was 7:15, and the seven o'clock news was over.

Maybe I was abducted by aliens.

The previous month we had taken a place upstate and all kinds of weird shit happened there, like big circles appearing in fields and weird dreams. There's one dream I remember better as time rolls on. In it, I am awakened by the sound of running downstairs. The house we rented was once a boardinghouse. It was big and had a center hall and staircase and kids would run from the front door through the hall to the right and through the living room into the closet that went under the stairs and then through the pantry out to the mudroom through the laundry room into the kitchen through the dining room

back to where they had started, all in one big noisy lap—
booom-booom-booom-booom-booom.

In my dream I got out of bed because someone had been running that lap now for a few minutes in the dark and kept on going, around and around. I got to the top of the stairs just after they ran by and before I could turn on the light. I couldn't see them but they were small, I could tell, because of their short, quick steps. I walked down the stairs and flipped on the light just as they were coming around the bend through the dining room and right into my hands. I caught him or her, or whoever this bald-headed old person was, wearing an over-sized red flannel shirt and bib overalls. And it was little and frail, like a hundred-year-old woman, and slowly it looked up at me and it had great big almond-shaped eyes.

That was it, my dream.

I think they might have followed us home.

The day my daughter was born I came home to find the door wide open and we had been robbed in the middle of the day. Somebody had known we would be gone.

After our new baby had been home for a while, the big toxic dump at the end of the street whose owners the govern-ment had been after for years to clean up the tons of barrels leaking DDT, caught fire.

Luckily the wind blew the black smoke full of burning toxins away from us—toward Brooklyn.

The condo we lived in had been built by a family from St. Louis who'd got a government grant to restore burnt-out town houses as long as they hired local neighborhood help. Our

building was the training model that they worked out the kinks on before they got to the end of the block and knew what they were doing. Those buildings were much better.

But the developers didn't care to fix our place, saying it wasn't "cost-effective."

That's a mouthful. It isn't "cost-effective" to fix mistakes in a house you built and sold.

Their offices were next door so they did fix the tilting wall you could see when you walked in the door, but when it came to anything else they brought out this "cost-effective" line.

Everything that could be wrong was wrong with this place; every door was crooked, every surface uneven, every light switch and outlet was at an angle. The basement filled with water every time it rained. I really couldn't relax knowing there was a lake under me so I would climb down into the dark crawl space, holding my flashlight, bending over and wading through the almost knee-deep water to restart the sump pump.

One time when I was heading back to the ladder I dropped my flashlight and suddenly it was pitch-black and I felt something bite my leg under the water. Then I heard a lot of things splashing into the water and swimming toward me and then they were crawling up my legs as I was trying to escape but I fell back into the basement floodwaters because they were eating my legs and then I died.

But I hated going down there and for me that symbolized just how fucked up and gross Jersey City was.

I told the developer that I had been ready to get screwed

over by New Yorkers when I moved here from Tulsa, but I had never dreamed I would get the biggest fucking from folks from St. Louis.

Not long before we moved back to New York I had a bad allergic reaction to penicillin and my throat air passages were closing. I felt like I was going to die so I got into the car and drove through the Holland Tunnel into Manhattan to go to the emergency room because I didn't want to die in Jersey City.

(I couldn't get anybody to come out to Jersey City to see my work so I rented a windowless studio above a textile store on lower Broadway. I called it the art dorm. It was full of struggling young artist.)

THE RAPTURE

Around the fall of 1986 I shed a skin, so to speak; some things became clear, and others fell away.

I had come from Oklahoma to New York four years before, and now I was moving into a studio on Broadway in a building full of small studios. There I met a young artist who had been born and bred in Manhattan; he mirrored me back as a redneck. It felt like the first time I was in Europe and seeing what being an American was like.

One day he introduced me to his thoughts on morals and what a limiting and silly idea they were, and how he would do anything to further his career. And he *did* do anything, like let his teacher cornhole him. He said he wasn't gay, so he had to

think of women to get through it. Shocked, but politely, I told him I wouldn't do anything. His response was quick: That's because you're a fucked-up Christian.

Bingo.

That's it, that's exactly what I am, I thought. (It was always in the background, culturally, but I had never really thought about it till then.) I went about recalling what I could of sitting in my grandmother's church and painted it.

My whole world pivoted in that moment and my sails popped out and the boat took off. Genuine content that I could elaborate on with authenticity. (Personally, anyway.)

MY ADVANTAGES

A lot of these young artists had a few things in common, like, say, they all knew this one kid who made it.

Take my friend Parker, for instance. Parker had known this other kid since nursery school and their fathers played golf together. Parker went to Yale and Cal Arts with the kid and watched him get famous using this shtick that was just lying around the studios, Parker said.

Nevertheless, the kid had made it.

So Parker and the others who knew him waited for an invite. They waited for the wunderkind to send the limo and stand with them at their opening and, of course, introduce them to his art dealer and collectors. You know, share.

Parker's and the kid's mothers knew each other, too; this

made for awkwardness when they'd see one another at the club. Because waiting to get invited—when that's all you need—is unfair and selfish, but it was even worse to ask for it, Parker's mother thought.

Parker tried to go to the right parties and openings and knew he was just one right introduction away.

He felt a tiny bit guilty about having it so easy, living in a top-floor loft his dad had bought with a view of the river, and that he didn't have to work at a job to be able to wear such nice sports coats.

We met through our children's playgroup so sometimes in the morning after dropping my kid off I would go over and have coffee at his rooftop studio and listen to him tell me about the in crowd that made his career look white hot compared to mine.

I was no threat to him and we talked about paintings.

Then one day I called him, excited to tell him that Thomas Ammann, a dealer from Switzerland, was buying my work. I thought he would be excited for me but he wasn't.

After some silent tick-tock he said he was demoralized.

This was the last straw, and he wasn't going to wait for me to come through for him, so he took it upon himself to go and track down the art dealer who had brought Thomas to me.

Then he called me later, angry, because that art dealer— not knowing why Parker was in his face saying, If you like Joe's stuff you'll love mine—didn't love it and told Parker a long story about what it was he liked about mine.

With that, Parker said, he had never been so humiliated

and he was calling me to point out all the advantages I had over him. He said he couldn't live up to how I grew up kind of poor on the edge of town and having to sit through my grand-ma's church and hanging out with white trash in east Tulsa.

THIS WOULD BE THE DAY ALL MY DREAMS COME TRUE

It was murder. I was thirty-one and had been in New York for almost six years and had nothing much to show for it. Then I found someone to stick a few paintings in the rear of his gal-lery, only to have him ignore me and even hang up the phone on me when he realized I wasn't another artist with a very similar name. Then one day he called me, hysterically excited because Thomas Ammann had bought all three of my paintings and wanted to see more. They were coming to see me. Now.

Who's that? I asked. You don't know? He's the biggest thing that could happen to you. He's from Switzerland, an art dealer, a collector. He's good friends with Warhol and we'll be there soon.

Later he called from a car. This is before everyone had cell phones. I got up to let them into my dark basement studio. They got out of a stretch Mercedes limo. There were five of them and my "friend." They looked like movie stars. I had never seen people like this up close. Their skin was perfect, they were thin, their suits were dense and dark, their shirt collars stiff and white, the same with the cuffs. Their jewelry

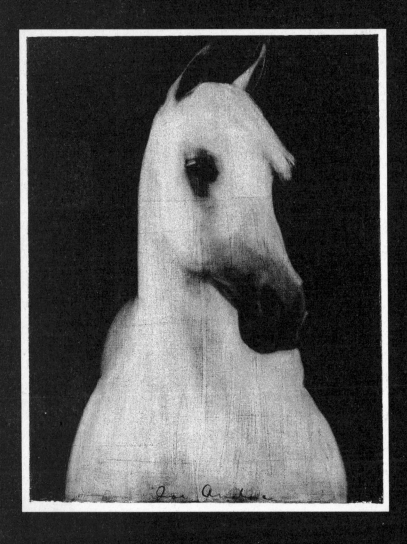

was heavy and large, their jawlines were sharp, their shoes hard and shiny. The woman's fur was thick around her shoulders. She had beautiful calves and was wearing high heels. And me in my favorite green plaid shirt, my hair hanging down past my shoulders and messy. I needed a shave. I could not be more different from them.

Thomas sat in a chair in the middle of my studio, polite. Everyone else stood silent for thirty minutes. I crouched near the back window, nervous, and smoked cigar butts, as Thomas decided to buy all of my paintings. I worried about the limo driver. Was he thirsty? Or did he need to pee?

THIS WOULD BE THE NEXT DAY AFTER ALL MY DREAMS CAME TRUE

That art dealer took me out to a fancy lunch at Aquavit after Thomas left and acted like he was my best friend as we ate on white tablecloths and had two bottles of Bordeaux. He told me his darkest secret when he pulled his pant leg up to show me ulcerous deep scabs on his knees.

He explained that he liked to have sex for hours on the rug until his knees bled, and do it again before they healed.

This was someone who wouldn't return my call the day before.

After lunch he staggered back to his office and called everyone in his Rolodex and told them about Thomas.

That was the first night I didn't sleep well.

Before that I had been a champion sleeper. I could sleep through anything.

Not after what happened that day,

I lay in the tub in a few inches of hot water and worried that this was my Fifteen Minutes.

Sleep was never the same again and that was the price.

But the ride continued for the next two months. We sold almost everything I made. Then I ran out of money.

I went to my dealer and said, We've sold twenty-some paintings and I haven't been paid anything and I need it. Art supplies have busted me.

But an even bigger concern was that tuition was due at my kid's preschool, the one that we'd tried so hard to get him in. I had spent all that money on new paint and canvas. But I didn't tell him that.

He said, I tell you what—I'll buy those five paintings I saw today in your studio for $1,500.

That's what just one costs at your gallery, I say.

That's the best I can do, he said.

I said, But doesn't so-and-so collector want those at fifteen apiece?

No, I want them for my collection, he said.

I was in shock and said, Do you mean to tell me we sold all that work and you haven't been paid and now you're taking those five off the market and want me to sell them all to you for the price of one?

I couldn't believe it.

I said, Let me think about it, and hung up.

I called back the next day. I was so pissed off and humiliated but I was also broke so I told him, Take your fucking paintings but pay me today—I need to pay my kid's nursery school with it.

Then surprisingly and slyly and slimily, just like a snake sticking his head out of shit he said, I don't want to give you money for that.

I think he could tell that he had pushed me too far because he did pay me.

And so he bought the five paintings and I still hate him, especially when I think how happy I had been to be in his gallery and how I gave him a painting and one to his assistant, who didn't even like them.

I had seen trouble coming a few weeks earlier when one night he called and told me his sister was meditating in front of my new paintings in the back room of the gallery and he wanted to know if I would give it to her.

WHAT?

The only speck of generosity he ever showed me was when my boom box broke and he loaned me a paint-splattered one with a clothes hanger antenna.

After his fifteen-hundred-dollar check cleared I surprised him when I showed up at his gallery, sat that piece-of-shit loaner boom box down front and center on his desk and said, Deal me out.

Over the next decade I came upon many gallery people cut from the same cloth.

One year I was broke and one of my main art dealers came to visit and fell in love with my best painting.

He wanted it but said he would trade it for another one of mine he had in storage.

Because he had bought a few of my paintings over the years (at half price), I agreed to the trade.

When the truck came a day later I traded my best painting for the one I had given him for Christmas the previous year.

His business partner had once sold one of my gift paintings at auction, but before looking at the back of it. That was transcribed in the catalog: Merry Christmas and another great new year. Yours truly, Joe.

He couldn't spin that, so in a rare moment of humility he told the truth: he had thought I was making fun of him because it was a picture of a cow and he had had trouble with his weight his whole life.

About this pattern of one-sided giving my wife said, Joe, what makes you happy is making other people happy and what makes them happy is to get something for nothing.

MERCY

I was miserable: it was really late and I didn't have the right change for the under-the-river train from the World Trade Center to Jersey City.

I had been out with friends, doing coke, smoking pot, and drinking.

But I wasn't holding any of it and I didn't get enough, and that's worse than not doing it at all.

Here I was at the PATH train in the basement of the World Trade Center and all I had was a twenty. The change machine wouldn't handle that and the only other option was the deli way the heck back up the five-story escalator, back through the mezzanine, out the side door, then way on the far corner.

So I jumped the turnstile. I looked at the clock and it was almost four A.M. The trains are few and far between at that hour.

I needed to pee. There were no restrooms.

I stood like I was reading the paper and peed in a garbage can.

I looked up and saw two cops coming at me.

At least they hadn't seen me pee.

They arrested me.

I didn't have change, I said. I take this train every day.

I not only showed them my driver's license, I showed them my American Express card, to prove I wasn't a bum.

I told them I was married and she was pregnant, that I had a condo and a kid in Jersey City and I needed to get home because it was late and if I didn't get home soon my wife would make my life even more miserable than it already was.

Down in the office, the Port Authority policeman wanted to call the house.

I felt dread turning to a cringe when the policeman said, Hello, Mrs. Andoe?

The cop frowned and held the phone away from his ear

and said, Sorry, Ms. Smith, I didn't know you kept your maiden name. Anyway, I'm Officer Holly at the World Trade Center PATH station and we have your husband here because he jumped the turnstile.

The officer suddenly held the phone away from his ear again and we all could hear her screaming, HOW DARE YOU WAKE ME UP? FUCK YOU! LET HIM ROT DOWN THERE.

The policeman said thank you and politely hung up.

He looked down and couldn't look me in the eye and said, You can go. You got enough trouble.

FACTORY AIR

I know boys. I'm the oldest of four and I have a son.

No sister.

Boys are like dogs—low maintenance and easy to manage if you show them up front who's the boss.

But girls have always been a mystery to me.

I had girlfriends but . . .

Girls had voodoo; they conspired telepathically so boys couldn't hear.

They practiced a dark martial art; they could whip my ass by using my own energy against me even if I was just trying to defend myself.

Then I had a daughter and right out of the chute I could see she was a whole other thing.

The second she dropped into the doctor's hands she was inconvenienced, cold, and pissed off because she had been just fine moments before.

She fussed with a bitter intensity.

The nurse brought her up to her mother's face, who said, Hush, and my daughter quieted and turned her head and looked toward her mother and, at not even sixty seconds old, she must have downloaded all kinds of things right there in front of me that I was too slow and stupid to see, or it could have been communicated at a dog-whistle-high tone that I couldn't hear.

Shortly, I learned . . .

. . . that boys' rules and regulations were meaningless when it came to her.

While I had huge Viking hammers, she required fine delicate Swiss watch tools and somebody with the motor skills to use them correctly.

It was as if I was a blind man trying to eat canned peaches with a spoon. I had never failed so bad at anything before.

How did she know how to do this?

One night I came home after I had been away for a while. She was only six months old, but she refused to even look at me.

I had to grovel, send flowers, kiss her feet, pull her toes, tickle her tummy, and sing a song I made up on the spot about how I loved her more than anything in the whole wide world, before she turned and the sun shined its most beautiful glow.

Then, with his perfect timing, my five-year-old son popped up with a toy gun and had to tell me something that took all my attention . . .

Away from her.

She cried.

I don't know why I didn't see it at first but on her receipt it said plain as day that all this was standard equipment.

SECRET

My father-in-law hid his drinking and so when my in-laws would come east for visits I would make sure he had a stash.

It all started after the kids were born. One summer we rented this big place in the Catskills. It used to be a boarding-house; there were ten bedrooms and a barn to paint in.

Of course, my mother-in-law thought we were sinful to "abandon" our home in the city and rent this one in the country, just to mess around.

There wasn't enough stress so she provided it.

She harped on everything from the fact that we used pure maple syrup to the drawing she found that I'd done of a guy sitting on a bed, looking conflicted, with all his fishing gear around him and a sexy, naked woman standing there tempting him not to go.

So on her docket I was now tarnished with being nasty, too.

This was so unnecessary. It was a beautiful place on fifty acres, it didn't cost that much, and I was working in the barn. But she felt it was bad.

She was so sour for three days and on the fourth it finally got to me and the kids picked up on it, too, and my son acted out and I scolded him. He wouldn't stop crying. This was when her heart soared. A million dollars wouldn't have made her happier. She took the baby and waltzed through the many upstairs rooms and sang hymns like an angel.

I drove into town and bought a fifth of Bushmills fine whisky and brought it back to the house and opened it and poured myself three fingers' worth. I left the bottle on the kitchen counter with the lid off and walked out to the back porch with my warm glass of whisky and there was my father-in-law lying in the hammock with his hat pulled down over his face.

He peeked out and I saw the look he gave my glass of whisky and at that moment we became other than them.

I handed him the glass thinking, He will just take a sip, and he downed it all without a word.

I turned around and went back in and poured myself another. I took a sip and walked back out onto the porch. He gave my glass that look again and I handed it over.

Without saying anything we repeated this twice more before I returned and his hat stayed down.

And then we were secret allies.

THE BLUEPRINT

We moved back to Manhattan in style, to a nice place with a lot of possibilities. It was on Franklin, a quiet wide cobblestone street—the best street in the best neighborhood in the best city in the best country in the history of the world.

Like John Lennon said, This is Rome.

We bought it at the lowest point it will ever be. Right before the market shot up. And we fixed it up, but stopped at the kitchen and bath because those were biggies and I didn't want to do it right away because I was tired of renovations and all the stress and cost but she wanted it bad and pushed, so what did we do? We went to Maine and rented a house for the summer near "Christina's World" and the lobster capital, under a dark blue sky and the whitest, puffiest clouds and a view of the ocean.

The renovation in the city about did us in, and our plan to keep the loft open looked nice as long as it was clean, but not having any other rooms was a killer. It didn't matter that it was a fairly large space, it was still just one room and you could never get out of the eyesight or earshot of the other.

Build rooms.

We had a bad fight on the way to Maine so the first night I slept in the spare room. And every night after.

We just went through the motions. She went to the beach with her friend and the kids, and I stayed in the barn and painted the same view of the same water and the same tree every day and ended up with fifty-seven paintings that look almost the same.

They are still mine.

Then her parents came to visit and her mother lay off me because she noticed I wasn't sleeping with her daughter and was hanging on by a thread.

One morning she was doing the dishes and I was sitting at breakfast and I asked her when had been her daughter's happiest time.

She thought for a while as she washed before saying, I guess she hasn't had it yet.

When we got back from Maine, my wife pushed again for the new kitchen and the new bathroom that we needed but having just had such a refreshing time outside, away from the city, made me realize just how much I missed the outdoors and being around plants and trees and all.

Being outside in nature was always a big part of who I was but it wasn't for her and she took that away. That's something that can be taken easily when you are tied to someone who has never even looked at the stars.

When we were first together and in Colorado one night and the light pollution was nil and the sky was out of this world and the moon was full, I pointed up and she just glanced up like you would at the sun and asked if that was a star.

She was nearsighted, nearly blind, and wore thick glasses or contacts that hurt her eyes. She liked things that were close-up, so she preferred being indoors or in the city, maybe a beach, where you could look at the sand and the water was right there, but she did not like the open-ended and undefined.

By now our fortunes were looking up and she had her dream house in the city and it was a good solid home for the family. So now it was my turn. I wanted something that would make me happy and be good for our marriage. I wanted a car so I could restart the part of me that was forced to stay indoors all those pretty days because that was what she wanted.

I came up with a plan that would keep us going a little while longer. I thought that maybe I could look for some little place a few hours away. It wouldn't cost so much but would be under a big sky and I could hear the sound of the wind instead of traffic, but no, she wanted her kitchen. I made my argument that a natured-out Joe would be happier and paint better and then she would have everything she ever wanted—eventually.

She didn't like any of it, especially the "eventually" part.

And then when I said, I would think you would want me to be happy, she said she wanted me to move out.

Inside my head it was both thumbs up—YES!!!—because I had just won a twelve-year-long Mexican standoff.

I couldn't leave her in the early days because of money, then it was our kids, then it was because I didn't want to be the bum who divorced the wife who helped him. The car was just a way to stretch it out some more and keep things going a little longer.

So folks, this marriage that was jury-rigged and held together with bailing wire and tape and momentum and bad habits and dysfunction died on kitchen hill.

We stalled out and couldn't make it over.

I couldn't get it to start again even if I had really wanted it to.

This next line is a testament to how stupid a heart can be: even though we hated each other, still it was sad that she gave up on us because she was the one who had kept pushing us back onto the road when we veered off.

I would be done with her and sick and tired of the fights and her control issues but when she saw that it had gone that far she would rally, put her diaphragm in, and cook something I liked and say, We've got a lot of things to do. Then I would be back in the saddle, bandaged up and looking like the misfit Montgomery Clift after the rodeo but I'd be good to go a few more clicks.

Not this time.

But the next day I was feeling sentimental. I made an attempt to take on the role of being the one to get us back on track. I went into the closet and pulled a roll of hundreds from my old cowboy boots and handed it to her. It was my whole nuclear winter escape fund—my car money—and that was the last time she ever smiled at me.

And that was the stupidest thing I've ever done.

The day I moved out I said to her, You know, the whole time we've been married you have never done anything designed just to make me happy.

And she said, You're happy enough.

FALLINGWATER

I was almost in the clear. Not exactly emancipated, but out of there. It was moving day and the only tangible job skill I had ever had came under the heading of "carrier of heavy things" or "ditch digger," a laborer or something. I could probably teach you how to paint a little but I still enjoy a good carry. This day I was carrying my best stuff and the movers were carrying the rest.

I didn't have much of the good stuff left because I gave it all to her, including the loft.

I stood by the elevator in the good light and was examining what I had got away with—my prize piece of furniture, a Frank Lloyd Wright headboard, made by the furniture company Heritage Henredon in the 1950s.

I stood there by the window admiring it, waiting for the elevator. It was, as far as I know, from the only mass-produced line of Wright's design done during his lifetime. Now any real midcentury furniture snobs would be too good for anything mass-produced like this, especially from a middle-brow furniture company based in North Carolina. But for me, it addressed Wright's eye at his best and at his most challenged. A lucid design made to withstand an endless edition, with the last one being just as perfect as the first.

It was just a simple wooden rectangle with a slim but bold Egyptian-like scroll around its edge that closed the deal with perfection and grace, giving it the perfect pitch. I carried it myself because just one scratch would ruin the balance.

It was still early when I carried it out to the loading dock of our loft, and just then passing right there, three feet below on the old Tribeca sidewalk was my four-year-old's nursery school class. Twenty or so kids holding on to a long rope, each had a designated handle; and there was my tiger, my sweet darling, who I hadn't had the heart to explain this to yet, who just happened to be passing by. And she saw me carrying that wood thing that belongs upstairs next to the bed, and why is our kitchen chair out here, and that table doesn't belong outside.

I just waved as she passed. I couldn't stop it. All I could say was, I'll see you after school, and she looked back as her class kept waddling away and she was the only one looking back with all the puzzlement a four-year-old can have.

If I could trade that headboard for that moment, I would; shit, if I could trade every piece of furniture Wright ever made, or how about every piece-of-shit Usonian house, and hell, throw in the Imperial Hotel in Japan, and I would let his so-called masterpiece Fallingwater fall into the fucking creek, if only I could have that moment back.

SPIRAL

I found it surprising how quiet it was outside the house and it was disorienting without those boundaries.

I was thirty-three, the same age as Jesus at his crucifixion.

It's a tough age.

I moved into a shitty little studio apartment where I spent half the time being totally alone and the other half having both kids sleeping with me in the same room, sometimes for weeks on end, the three of us crammed together there, all the while waiting for some finalization so I could rebuild my life.

I was quickly running out of the little money I had left and my work suffered and my income dropped because I was stressed and overwhelmed by laundry and grocery shopping and making sure I was set up for the kids' visits. I was being a single dad in New York City.

As a result I was drinking and drugging when I wasn't being a single parent. Lois, my dear mother, said she had never felt sorry for me in my whole life except for when I was married and she really felt sorry for me being trapped like that because she knew how much I liked being trapped.

(FYI: Lois didn't start out such a great mom but she is finishing strong.)

I had lost my new house and was losing all my money. On the nights I didn't have the kids, I had a lot of steam to blow off. Before, I would do coke and drink hard once a week, but now it got much more common and I was drinking almost every day they weren't with me, leaving me trashed when they showed up.

I was hanging around this young writer, and it almost killed me. I had met her four years before when she did a profile on me for a magazine that folded before her piece came out. She was an upper-crusty Smith College grad and she was addicted to heroin.

I had total respect for that drug. I had seen what it had done to my friends back home in the early '70s.

I thought I knew what dying from coke would be like, and I could guess what an alcohol death would be like and how you would probably be able to see it happening, but the end of heroin is over the curvature of the earth and way past where you can see and I just knew that those who went there never even knew it.

But one night we were speedballing at my little place, doing coke in a big pile and heroin in a little one, and they got all mixed up on the mirror and so I did way too much and overdosed. She left me lying there after stealing all the dimes and quarters from my kids' piggy banks, and I lay there for two days and I never did heroin again.

I almost lost the plot that night.

This weakened me but I didn't stop drinking and I was smoking two packs of cigarettes a day and still snorted coke, but it didn't stop the bills from coming and the kids visiting or stop our tenant in Jersey City from moving out or from having those big circles I was making around the drain from getting tighter and not having the power to do anything but to watch it happen.

My biggest regret from this whole period is that even though I was consistently there for my kids (and I have pictures to prove it), I have no memory of them—of who they were or what they were like or one cute thing they said or what their little dreams were.

HELP, I'M BEING KILLED

The opening was three hours long and it was crowded.

There was a band.

Hennessy sponsored a free bar of all kinds of martinis.

Patricia, my Aspen art dealer's wife, was someone who loved company so she kept a martini in my hand the whole time.

Then I got really drunk.

I lost control. I pinned different women into corners and tried to kiss them. It was inappropriate to be kissing married women who are curators of museums, uninvited.

Then the opening ended. Everyone went next door to the Woody Creek Tavern for dinner. I was the last one to get there. I had more spooning to do with this reporter from the paper as the band played one more song just for us and we hugged in front of them.

I finally got to the restaurant and I spotted the bar and ordered a gin and tonic in a pint glass and made a few new friends before I walked over to the long, pushed-together tables where thirty or so well-wishers were waiting for me and I sat down near the end and lay my head on the plate. While I was looking down the table at everyone they were looking back at me, and the table started spinning. So I stood up fast to make it stop and knocked over the waitress's giant-size tray, spilling my party's drinks on the floor.

There was a moment of silence and then she said, her face up close to mine, Get out.

I can't, I slurred.

Get out, she said, louder this time, pointing behind me toward the swinging door.

Sorry, but this is my—

Cutting me off she said loudly, Get out.

The place got very quiet, I was told.

Then I said, fast before she could cut me off again, This is my party, these people flew over mountains to see me. I'm so sorry. I'll pay for it.

She looked me in the eye and said softly, almost in a whisper, Fuck you.

That got my attention and I was in the moment now. I studied her face and asked her, Are you suffering from vaginal dryness?

She hit me as hard as she could. Knocked me down. Next thing I knew I was being dragged outside and propped on the bench under the streetlight in front of the tavern, dazed. After a little while I started to realize just how bad I'd been dissed in front of my opening dinner guests. And went back in.

The whole team—the bartender, the waiter, the cook, the dishwasher—dragged me out again.

This time I tried to get back in immediately, but they were holding the door shut. But the door swung both ways so I pushed and rocked it but it wouldn't open all the way. I yelled and I pounded and pushed more but they held tight.

The police came. She wanted to press charges for sexual harassment but since she had hit me we were even, the cop said.

I woke up early the next morning further down in the valley, to the sound of my heartbeat on the pillow and pounding in my eyes. My head had never hurt so bad or my mouth ever been so dry or the vomit so bitter. I drove the fourteen miles into town looking for relief in the form of pancakes and coffee. I stopped at the first place I came to at the edge of town.

It looked like a log cabin.

I was poisoned from all the alcohol. I felt like I was dying. So I bowed my head and prayed and vowed that if I could just feel better I would never get drunk like that again. Then I waited for mercy.

Out of the corner of my eye I saw a waitress's red-checkered apron and pad.

Relieved, I looked up and it was *her*, the same waitress who had hit me only hours before. She had two jobs and she said, Fuck you, get out of here, and walked off.

Please, I yelled. I'm sorry. Please, can't you see how sick I am? I feel so bad, can't you help me?

She ignored me as she waited on others.

And then she hissed whenever she walked by. And every time I heaped on a big serving of apologies. She could see how red my eyes were and how green my skin tone was.

Then she finally served me.

After I ate I started to feel a whole lot better and she got kind of sweet.

Her ass got kissed really good. Then I lay down a ten on top of a four-dollar tab.

She hugged me as I left.

The art dealer had worried that it looked like a publicity stunt because my New York dealer had heard about it in Tuscany.

And the last I heard of her, she asked when I was coming back.

(I didn't know it at the time but I had accomplished something that even Hunter Thompson couldn't and that was to be eighty-sixed from the Woody Creek Tavern. I don't think he ever tried very hard; he had only shot off firecrackers and smoked his pipe inside.)

KINDA LIKE MY OLDEST FRIEND

It was good news until I had to tell the kids.

But I didn't love her, even though she had been my wife for twelve years.

So suddenly there I was with a lot of free time.

At first I would go meet friends for dinners and drinks in bars. I did coke and sometimes heroin at least once a week, sometimes more, usually on Monday or Tuesday nights. My place was cramped and when the kids came over it was tough. Then I got worse, more drugs and booze. I quit doing the smack, though.

I started to run out of money. I had to move back to our old condo in Jersey City. The renter moved out. The plan was to fix it up and sell it. It looked horrible. The second the movers

left me there I screamed like I was being electrocuted. The screams fought to leave my body. This was the place I had lived with my family for seven years. There it was. It looked like shit and I was stuck. I drank a lot and did more coke. I was at my lowest. It was so far away from the kids, and my life. I couldn't sell the place; no one would buy it—bad neighbors, poor neighborhood, overpriced. My ex didn't care. She was happy and I was alone.

Then one night I was in the shower in the shitty beat-up condo in Jersey City, so far out, where the tide of the yuppie scum of the '80s real estate boom collected at the very far edge, barely walking distance to the train.

So there I stood in the basement shower, depressed, weak, sick, and hungover, my head under the water. I felt like I was on the dark side of the moon. I was never so sick and low, never more alone . . . when I saw there, on the edge of the tub in the shower with me, that toy Charlie Brown with the goofy smile and red shirt with that zigzag on it, about ten inches tall. The kids must have brought it from my mother's house in Tulsa, because I had never seen it here before.

It was one of my first toys, a toy that I had never paid much attention to. I never really knew what to do with it, I guess, but it had always been lying around, always smiling like that. I had three brothers, all younger. It must have passed through each one of their hands and lain around for years and got all marked up, kicked, and scarred. Speckled with house paint and ink, dented by bite marks, it was scuffed and scratched but standing there, smiling.

I wondered how out of all of the hundreds of toys I'd had throughout my childhood that this one, my first, had not only survived but was here in the basement shower in Jersey City, smiling at me.

All of a sudden I didn't feel so alone; it was like he had hung around all that time until I needed him.

(I have been giving him a prime spot ever since.)

MILKY WAY

My new girlfriend was a four-star chef from Seattle, and when she came to New York she would take me to four-star restaurants. We would meet other four-star chefs and eat their food. This was new to me, to eat at places that had stars. Once she took me to Bouley, the mecca of restaurants in 1993, a restaurant at the top of the top where all the brightest movie stars, sports stars, and media stars ate. We usually ate for free at these places because she had her stars. But here we felt lucky to even eat standby. So as we waited, we drank a great bottle of Chateaux Margaux and got acquainted with a couple from Texas—a big, white-haired, rich fifty-six-year-old owner of a lawn mower company and his thirty-eight-year-old secretary who had a kid. He was married and she wasn't (hubba-hubba). The restaurant was crowded and the maître d' told us we could eat sooner if all four of us would sit together. We settled together at a big round table in the middle of the dining room. The rich Texan said, It's on me, and he ordered the ten-course

sampler menu for four with a bottle of wine to complement each course. The Texan was a foodie and my date the chef narrated each course, explaining the motivation and mechanics of the meal. The red-faced businessman loved that. After the seventh course the secretary lay her face down between the plates. She was out. The glowing lawn mower mogul looked down at her and smiled, then looked at me and the chef, winked, and said, She's got a great ass. After the eighth and the ninth wine bottles were opened, my four-star chef from Seattle ran for the restroom and she didn't come back. But the businessman got the biggest laugh when I stood, looking pale, and staggered out through the arches of the starry palace. Then I puked on the brick steps that led to paradise. I puked again and then had a moment of clarity; a realization that in such distant galaxies with so many stars that normal laws of nature don't apply, total strangers could buy you thousand-dollar dinners that you don't even have to hold down.

(Some weeks I did hardly any substances and started to enjoy my growing kids. But I did it in a vacuum as we had no extended family or any support group. It was just them and me. We might as well have been on a desert island. I didn't even have anybody to tell when they did something cute.)

GOOD ENOUGH

It was the first time I'd talked to James since he got out of prison after two years.

He called from Tulsa to tell me what had happened.

He said that he was dealing crystal meth for these criminals and one night he had a big bag full of it and partied with a go-go dancer till the morning, when he took a muscle relaxer so he could go to sleep.

He woke up later that day and she was gone and so was the ounce of speed.

The drugs didn't belong to him and he couldn't afford to go into the red with the owners.

So he got his pistol and stuck it into his boot, got on his motorcycle, and rode way down on Riverside Drive to her apartment where he found her without the drugs.

That was when he pulled the gun on her and she told him where she'd left them. He held the gun on her until she got on the back of his motorcycle and they rode back into town where he recovered most of the stuff.

Then he took her back to her place.

Relieved and hungry, he stopped at a hot dog joint called Coney Island and was starting on the second one when he felt something cold, pressed in hard behind his right ear.

Put your hands out where I can see them, the cop said.

She dropped a dime on me, James told me.

She lived right there next to the river, he said. I could have killed her and dumped her right there; she would have floated away, and I probably would have gotten away with it.

But he didn't and couldn't and wouldn't. I know him.

I remember when we had to work at the zoo, there was this

huge orange orangutan that was mean and wouldn't let anyone close to her without getting spit on, yelled at, or having shit thrown at them.

But she loved James. She would lie on her back, bat her eyes, act coy, and stick her long fingers through the bars as if she were slayed, and James would sweet-talk her and give her cigarettes and candy and hold her fingers and court her. Only him.

Then over the phone that night he told me that it's tough to be forty and back to zero. Having to stand at the bus stop waiting for the bus to take him to lay brick somewhere. He said he waited as the world passed him by in new cars and nice homes and things. That he needed to catch up so he had decided to do a couple more jobs for those criminals.

Before I could give him a sermon on the virtue of waiting he dropped this on me: If I don't come up with three thousand dollars by tomorrow, they will kill me.

I told him I wasn't doing so great at the moment.

I didn't think he was telling me the truth.

But he definitely wanted it that bad.

I don't have three thousand, but how about seven hundred?

He jumped on it saying, That'll do.

(Sometimes I marvel at how well I got away with it all, so untouched, and survived all kinds of shit without any drain bamage.)

SPIRAL 2

I put a FOR SALE sign on the house and lowered the price to about half of what we had paid for it and moved out.

She wouldn't help, saying it was my fault I was getting out when the market had gone down, or some bullshit. So I was stuck with that bill, too, and I ended up writing a check for seventeen thousand at closing; that was money I borrowed from somebody I hated to borrow from. But I was done with Jersey City, and at a bargain, as far as I was concerned.

I don't really remember much about moving into the Chelsea Hotel, but I do remember trying to stop the excessive partying by spacing it out like I had done for so many years, and it was going pretty good for a while. I would go for about a week where I would have just one beer a night or a glass of wine with dinner.

And here's a peek of how well that went: after working all day I was having my one beer at the bar of a restaurant that a friend owned and I was drawing on a napkin, ideas for new paintings, and there was one I was going to start on bright and early the next morning. I was just paying up, and this hip-looking Asian dude next to me at the bar says, Want a bump? as he did one on the top of his hand under the bar just below the horizon and then poured some more cocaine out on the top of my hand and I bent down and did it and instantly forgot about my big plans for the next day.

At eight o'clock the next morning I left this unmarked after-hours club somewhere in the twenties and I was standing

at an outdoor ATM and as I waited for it to process even more money to buy even more cocaine I saw a chilling sight: a kid my son's age being walked to school.

Then it was later and it was really hot at 1:30 in the afternoon and I was sitting buzzed out of my fucking gourd and the light was pouring in the south-facing windows in my one room with the bathroom in the hall at the Chelsea Hotel where the kids stayed with me half the week. And there was my fashionable Asian friend and this other guy who talked a lot, a tall blond roommate of his, and a short blond go-go dancer, and two dudes who had been following her around all night, and they were all sitting on the beds and I was drinking a huge can of Foster's beer and I was facing away from them at my desk as I emptied one of my last smokes to fill with weed because I had run out of papers and then the Asian dude was standing behind but over me and was all pissed off and on my case because he thought I was holding out. He thought I still had more coke and I told him I didn't and that if I did, believe me, I would do it right now and that was why I was trying to get this joint going.

He stayed to smoke the joint and to fuss at me some more and I thought he was crazy because I would remember if I had any more coke, and then he walked out in disgust with all the rest, leaving me there looking for my keys and some money to go and buy some more cigarettes because I needed a cigarette bad, and when I reached into my pocket to make sure I had my keys I felt something that I hadn't felt last time and I pulled out a tiny bluish Ziploc bag half full of cocaine, about half a gram.

I didn't remember where it had come from but that didn't

stop me from snorting the whole thing at once before I hit the hot sidewalk for smokes and beer.

Then I was outside and it was hot and bright. I could barely see. I felt like I was walking on a trampoline, a big, soft one, going uphill. I didn't think I was going to make it back but I did and I was blind and disoriented coming into the dark lobby from the bright outside and everything was a blur, and then I heard Victor behind the desk say, Mr. Andoe, the elevator is to your left—over here, sir. I went over to the elevator and then he had to tell me where the elevator button was; I had been poking at the fireman's keyhole.

About that time I stopped everything. Then I got the flu. That was probably detox.

HOME SWEET HOME

I woke up and found myself in the mirror above the blocked-up fireplace. I recognized me from a long time ago.

Before I was married, before the kids. Before the divorce, and before I lost it all and ended up in this one-room with the bath in the hall at the Chelsea Hotel.

SPLAT.

There I landed and it's there I started again.

SLIGHT RETURN

Then I flew up and I had never felt better, really never better, and so I decided to stop for good and had gone about nine days when I saw a woman at a benefit who was stunning. I just loved the way she looked. She wore tall riding boots and some cool-looking short fitted jacket and she was a brunette with Chinese-style straight hair, cut in a pageboy. And the next day I got on the phone and called the one person I knew who knew somebody I saw her talking to and lo and behold a dinner was planned for us to meet.

I was clear.

I had stopped drinking for good.

We didn't talk much at dinner. I was distracted and amazed by people's wine habits and how they left so much wine on the table in glasses and bottles. I noticed because I had never wasted wine like that.

But I was done and I didn't drink that night.

She was a beautiful ex-professional ballerina, now an architect, and I walked her home to her Upper East Side rented one-bedroom penthouse but that night she wouldn't let me close the deal or let me stay. But the next night we went from zero to sixty in no time.

In a month we were talking about "us" in a big way, and in two months she was looking at co-ops in Carnegie Hill for us and maybe a baby.

I was really optimistic.

But she had no appreciation of what I had been through.

She was from a whole other world. She was an Upper East Side type A+ plus—a superpolished, high-maintenance, straight-haired Jewish girl whose family was, she claimed, from some Far Eastern tribe.

She had different ways of getting by or over, like going to Barneys and picking out whatever she liked no matter the cost, then going straight to a fabric store to buy matching fabric, then heading up to Central Park West at about 100th Street to a woman who was an ace sewer who did all the clothes for some sewing magazine and could sew better than the Armani that was brought to her. She'd copy it fast, by the very next day, and then my new friend would return the Barneys outfit for full refund and have an exact copy that was even better. For a fraction, she said.

I took my favorite green plaid shirt that I had had forever and was now just threads and went and picked out some cool fabric and got copies made. I should have had the arms lengthened.

The only negative to our relationship, besides my daughter not liking her, was the fact that I didn't drink. That started to bug her because she liked to drink and she would say, You can drink, you know. You don't look like an alcoholic. I've seen alcoholics and you're too nice to be one.

The first few times she said this I tried to explain, but then I started to enjoy hearing her say that now that we were together it wouldn't get out of hand as now I was a lot happier.

Hmmmmm, I thought.

I had just a few days to go to making ninety days clean and I brought this up as we sat in a Mexican restaurant on the Upper East Side, just before she bought us two shots of tequila.

She said, We are not going an inch further unless I see you drink.

We had been together for probably eighty days.

I shrugged my shoulders, picked up the shot glass and toasted her, and knocked it back. Then I set the little thick glass down—*KNOCK!*

She did hers, too—*KNOCK!*

Then she ordered just one more for herself, just one, and as it was set in front of her I snapped my fingers and pointed to it and said, Are you going to share that with me? Then I got another.

She would later say that it was like a veil of mucus came over me and never left.

And we fought that night and the next night as I lay on her couch drinking her lousy wine and criticizing it and her cooking.

As we ate she was picking at her food and said meekly, You don't have to drink anymore, I believe you. You can stop now, it's all right with me.

She was so sorry that she had started it.

My attitude was, Sure deal, sweetie pie, but the dog is out of the yard.

And a few nights later I had one of my best shows on Fifty-seventh Street, with the work I had done during my

eighty-some clean days, and she was with me at my dinner for thirty at the Odeon and I was too coked up to eat or talk and Dennis Oppenheim, whose work I had studied back at Tulsa Junior College years before and who I didn't know yet but would become friends with later, was sitting across the big table and was heard to say, How long are we going to have to put up with him?

I wasn't sharing my stuff with anyone and she didn't know that I was sneaking around putting it up my nose and in my mouth so she kept wondering out loud why her mouth was so numb (because of the coke in my kisses), and my art dealer and his wife were disgusted even though we had sold everything that night. It must have been ugly to see me at a party being thrown for me, and me being so messed up and just sitting there with my girlfriend on my lap, not talking to anyone and not eating.

Later he told me he wouldn't work for me if this continued.

She said she was sorry she had wanted to see me drink. And we were done a few days later.

But I didn't want to stop drinking totally because stopping was just so radical and extreme. So I tried to manage it like I used to and that was like driving on ice.

If I tried hard, I could get to bed on time five or six times a week. And the other one or two days? Forgetaboutit.

(But still I started to get out from under a lot of crap because the money from my sold-out show was coming in and I was having more and more clean days and I moved into a nicer but still only one-bedroom sunny apartment in the hotel

with its own kitchen and bath that I didn't have to share with other apartments.)

A BAD GUY

I took my five-year-old daughter to the laundry with me. Even though I didn't see her every day, I thought it was important that we do real-life things together, like chores, and not just play.

The Laundromat was blocks away. While the washing machine was going, we ate dinner at a nearby diner. Came back and loaded the dryers. Then we played tag on the sidewalk in front of the Laundromat. The parking meters were base. Once the clothes were dry, the towels took an extra quarter. All the towels got done at once. My little blond five-year-old pulled a chair up to the folding table and proceeded to fold them perfectly. Where I folded them in quarters, she folded lengthwise in thirds, just perfect. The way her mother had showed her at home.

The Puerto Rican women who worked at the laundry melted; they nearly plotzed. Holding their hearts, rolling their eyes, it touched them in places little else could reach. This was nothing compared to the pride I felt as I watched my pint-sized wonder fold those towels. Perfect.

When we got home, my daughter pulled a chair up to the sink and washed the dishes. I couldn't wait to share this with someone, even my ex-wife. So I called her at home. Guess

what? I said. Tiger folded my towels perfect. The laundry women nearly died.

There was silence on the line.

Are you still there? Did you hear me?

She came back with a low slow voice. You don't get it, do you?

What, get what?

There was a sigh, followed by this: you are a sexist pig.

Click.

(I was using less and getting stronger and so I was living larger and wasn't under such financial weight. I had turned a corner with my paintings and that's when I met Elise.

We were fixed up by mutual friends because I heard she had become available. I had met her once or twice before and was awed.)

MOVE

More than a year together, the chemistry was beautiful, exciting, but it could turn deadly in a blink.

He had never been more attracted to anything, anyone.

She had been called the Marilyn Monroe of the East Village. An old New York psychiatrist, witnessing her entrance to a party, said he hadn't felt a sex vibe that strong since Marilyn Monroe. He knew Marilyn's doctor.

So this cowboy held on and it was hard to stay in the saddle, but when she was sweet, look out, there was nothing that could compare, nothing goes that high or that hot or that all-encompassing or offers so much contrast to the real world.

So he tied himself to the mast. He was welded in his kamikaze. The pain was tremendous.

He rode the storm.

He figured maybe she would even out if he made more of a commitment. He had heard that somewhere.

So he bought her a beautiful platinum ring, it looked like a fancy pull-top. She loved it. But soon she had her shit list about him and it was growing.

She told her people, her friends and family, the wedding would be sometime soon, but she didn't relax, she just got more pissed off.

They were in his apartment one morning and she was ripping him a new asshole about something. The phone rang, it was her mother. All of a sudden the tone of her voice changed. She held the phone to her bosom and said, in a much nicer voice, It's Mom and she wants to talk about the engagement party.

The cowboy was speechless; he couldn't form any words.

His mouth moved but nothing came out.

He saw her eyes widen, felt the blood leave his face when she said, Mom, I'll call you back, slammed the phone down, took off the ring, and threw it at him. Sandy Koufax couldn't have nailed him better.

And she stormed out.

In a few days they were tight again. But the ring was in a safe place. And they talked and they fucked, fought, and ate and slept together. He thought maybe if they just lived together this time it would be less pressure and she could relax and he would just get the sweet stuff. So she moved her cat and the many boxes of her life into his medium-sized Chelsea Hotel apartment.

Right away she got nervous, anxious. She would sleep until two and this was only the second day. On the third day he came home from work and it was after two, and she was still asleep. Why don't you get up? he said. You'll feel better. She flew up naked and wild like a buzz saw hitting him, and he blocked, blocked, and ducked. This cowboy hadn't defended himself this well in a long time. He grabbed her and wrestled her to the bed and was on top of her, holding her hands down. She was practically foaming at the mouth, her eyes were bright red. If her head could have spun around it would have.

What's wrong with you? he asked, still holding her down.

Get off, she screamed.

I'm not going to till you tell me what's wrong.

She said, I hate you, I really do.

He still held her down. Then finally she said, I get really depressed.

Is that all? the cowboy asked.

I have big problems.

Okay.

She relaxed.

I'll get up, he said, and let go. She lay there, naked, beautiful, and mad as hell. He stood away from her. She lay there fuming. Real calmly she said, Come here.

She didn't have to ask him twice with that tone. He went to the bed.

No, come closer.

He was at the edge of the bed when she kicked him in the knee. He dropped like a sack of bones and yelled, You kicked my knee, why the fuck did you do that? The pain was unbelievable.

She sat up and hissed, You pussy, you stupid hillbilly. What's wrong, can't you get up, you baby?

He couldn't. He really couldn't. His knee didn't work. Then he had a flashback to two days earlier when they watched *Saturday Night Live* where they were doing a *Goodfellas* skit. When the real Joe Pesci and the real Robert De Niro came out, Joe Pesci took the bat from the fake Joe Pesci and said, "You don't hit 'em over the head, you hit 'em like this, a fast, low blow to the knee." The fake Joe Pesci had dropped just like the cowboy.

The MRI showed torn tissue and bruised cartilage.

She felt bad, remorseful, and overcompensated with showers of service. But he was done.

When he came home the next day, she was gone. She left most of her stuff—her cat, boxes, and clothes were everywhere. He was devastated, destroyed. He missed her.

He knew it was crazy but even with all the crazy shit he was still in love with her.

A month went by and little by little he started to feel better, even noticed other women. But one morning he woke up and went to the closet and put his face in her coat. He could smell her, and he cried. He couldn't live without her. He called her on the phone, begged to see her. They had lunch, she looked great but she was bitter and sharp. After they ate she lightened up a little, then he blurted out, Please come home, please.

Later they were walking across town, each carrying one of her suitcases. He looked over at her, and she wasn't smiling.

Then he remembered how yesterday was not so bad.

He looked at her again and she looked like a powder keg.

Inside his head he went—FUCK!

THERE AIN'T NO LIFE NOWHERE

I called my older, very married art dealer and told him, She's only been here for two days and she's going bonkers like a cat in a bag. She won't let up screaming and yelling that nothing is right and she kicked the shit out of my knee. Only two days, man, I can't take this.

My dealer took a few seconds to respond and said, Why should your life be different . . . ?

(She moved back in only to move out again a month later, but I held on.)

MORNING GLORY

It was always sunny in her bedroom in the morning.

We had just finished having sex when the phone rang. She got up from the futon on the floor and answered it in the kitchen. She stood there facing away, just on the other side of the doorway, naked and awesome. I thought she was a goddess.

She said, Oh, hi Tina. It's nice to hear from you.

"Yenta Tina," I called her.

Then she spoke in hushed tones with her lush backside facing the open door. I couldn't hear what she was saying but from what I could see I was convinced that she was God's finest specimen.

I wondered how someone could be so slender and so plump at the same time. She was totally erotic and I felt like the luckiest guy alive.

Then she said, Okay, bye-bye, see you then, love you, too.

She came back into the bedroom with a mood change and a long face.

What's up? What's this all about? I said as I sat up.

Fuck you. How dare you listen in on my conversations? she said as she put on her robe. Get out.

What did I do? I smiled and thought she had to be joking.

Fuck you, get out of here, she said again, as she picked up my boots and threw them into the hallway—*bang bang*—and

then I was outside her apartment and she slammed the door behind me.

I had never seen anything go from so good to so bad this fast in my life except for a whiplash.

I sat outside on the floor by her door and slowly put on my boots.

I was devastated and confused all day long.

I called her repeatedly and wondered why she wouldn't pick up.

Finally she did, around five, and then warmed up to me during our second talk around six thirty.

We had a big reunion at ten, in her favorite restaurant with thick French wine and good food, just to her liking.

She looked unbelievable; I was really happy to see her and was so in love.

Back at her place we tumbled in the dark onto her bed. And she was totally hot like a porn star, but one who loved only me.

Then we slept and I held on as if she were a dolphin taking me way down deep, all the way to the bottom into the darkest, deepest, most private secret caves where we would be safe.

Like always the bright sun in her bedroom woke me first and I lay there looking at the bumpy white walls and the painted-over ancient light fixture on the ceiling of her three-room tenement apartment.

Then I noticed a huge bouquet of flowers in the kitchen. Big purple ones, nothing deli about them. How had I not seen them last night?

When she woke I asked her, Where did those big purple flowers come from?

She answered right away. Oh, Tina brought over this German artist yesterday who's visiting. He's always liked me.

FRIDAY THE THIRTEENTH

We were like that indestructible monster that you can't kill because there is still money to be made on yet another movie but finally what if instead of dying he got the message and packed it up and went home.

That was us, but there was a thread of gold that ran through it all that is still there in the form of a close friendship.

It was probably good that I had such a hard time getting away from my ex, or else I would have two exes now.

I started putting a lot more pressure on my ex-wife to sign papers.

We'd been separated for three years, for Christ's sake. It was so ridiculous for her to hold on like that.

She signed the divorce papers and it felt like the time I had my cast cut off and my arm floated up.

I floated up now.

I didn't need to self-medicate anymore because I was becoming buoyant and the bar was set so I could see how high I needed to jump to be clear of her and I could probably just float there . . . and I did.

Now let me tell you why I put up with her shit.

It was because I got to keep all my paintings.

I took all her abuse because she could have gone after my inventory. I have heard of courts giving an ex-spouse half of an artist's inventory, but she knew me well enough to know I wouldn't let that happen and how I probably would have put them through a wood chipper before I would let her get even one.

WATCH THIS

I was invited to lead a print workshop at Cornell University one fall during peak foliage.

There was this thick-spectacled, German-accented, middle-aged professor-looking dude hanging around who someone told me was a Nobel Prize winner in science. He seemed fascinated with printmaking, asking this and that and why was my name backward on the prints.

I told him that the finished print was actually the reverse of the etching that I'd made on the copper print plate. The printmaker inked the plate, then he laid paper over it and ran it through the press. The print that was made was backward from my original work. Instead of only signing the print after it's done, I sign the work on the plate before I give it to the printmaker. Since my picture gets printed backward, the signature comes out backward. I am not pretending it's not a print. And I like that.

But Mr. Nobel Prize Winner didn't buy it and he said dismissively, Maybe you're just not smart enough to write your name backward.

So right there on the newspaper that was taped down on the worktable between us I wrote, with a black crayon, big, legible, and backward: UOY KCUF.

ON THE ASTRAL PLANE

I have a very strong spiritual connection, she said.

She was young and cute in a furry way. She had a light in her eye and a bouncy soul. Nice conversation occurred. She said she was studying to be a therapist in Santa Monica. We talked more.

I sense you're lonely, she said. Do you believe in the inner child?

I said, Well, I think maybe I'm all child, in a way. I got two kids, I support a whole team of people, work for myself, but yeah, when I'm around people my age who work at real jobs I feel like a kid.

It's important having an adult, she said.

Maybe, I said, but I manage.

We talked more and I told her I lived in a hotel. Well, that's your inner child afraid of commitment and getting close to people. You need an adult, she said in an absolute and authoritative way.

Then I said, I see I pushed some buttons in you to cause you to assume such a position of authority. I don't see how you qualify. It's some female thing. You see me as being too free.

Calmly, she said, Now, Joe, don't get defensive. That's not what I said at all.

Then I said, You said my inner child needed an adult, and living in a hotel was proof.

Joe, don't get defensive.

And I said, You taking a position of authority that strong shows me that you are the one being defensive.

Calmly she said, Joe, I'm going to take a break, okay?

Then she went and sat at the other end of the plane.

THE COMEBACK

I was on my back on the operating table having a sinus operation.

After three shots I was still awake.

Then I went under only to wake during the procedure and screamed FUCK! OUCH! STOP! I opened my eyes and saw the doctor's arm above my face and it looked like he was jacking a car up and it felt like he was scraping barnacles from inside my head out through my nose.

They stopped and gave me another shot and waited.

At this point I hadn't had drugs or liquor in years.

They said that now I'd had about twice what is normal.

I was way high and fighting sleep; maybe I was enjoying this a little too much. I could see boredom in their eyes above their masks.

The doctor told a dirty joke to all of the help.

I thought my joke would be better and slurred, Hey, can I tell a joke?

They all looked at each other. The doctor was most inter-
ested in what the anesthesiologist thought, as she was the old-
est professional there, and a woman. And the best paid, I am
told. He looked back at me, apprehensive, and nodded yes.

WHY DID THE FEMINIST CROSS THE ROAD?

Then the doctor looked at the anesthesiologist again, then
at me, then back to her, and finally to me and said politely,
Why?

TO SUCK MY DICK, I said.

The last thing I heard was the anesthesiologist saying, Oh,
brother . . . and everything went dark.

When I awoke, I could see in their eyes that they are
really glad to see me.

Then the anesthesiologist kissed me on both cheeks.

Later the doctor told me that I had stopped breathing.

Why? I asked.

The doctor said, The anesthesiologist got a little carried
away.

(And just when I started to think that trouble was behind
me and that I broke the code and actualized and transcended
this base reality and that I was now operating under a law all
my own . . .)

OUIJA

I had an urge to paint the human figure all of a sudden.

I was in my forties and I hadn't started painting until I was

almost twenty-one. That was at the University of Oklahoma in an art school that was all about the New York school. In other words, my first paintings were abstract.

My art teachers encouraged me to paint tall, vertical, colorful abstract paintings. So, as Paul Gauguin would say, Art is based on nonconformity, so for my thesis I painted a black-and-white landscape forty-five feet long, and I disconnected the lights in the gallery so the canvas was lit by a skylight four stories above. When the sun sank, so would the light on my paintings.

The idea was that it should be actual—not a painting of something as much as the thing itself.

Since the late '70s I have fancied myself a landscape painter, and a painter of the things that hang around on the landscape. If my pictures could sound like music I would want them to sound psychedelic but real, like early country music, like what the Byrds did when I saw them at my first concert with my cousin Sambo back in Tulsa in 1969. Because my most psychedelic experiences have not been about fireworks and pinwheels but about stillness.

Like the stillness at twilight when animals come out into the open.

And when my brain waves are nice and flat is when things come out.

So in the studio, when something shows up, like a figure, it needs to be dealt with, because that's the only way I can find out why it's there.

One time horses showed up and I don't know shit about

horses except they were always around in east Tulsa. So when I painted the first one in my New York studio it resonated with me as if it were a symbol of what made me different from the eight million other people outside.

And I remember thinking in the '80s how strange the '80s looked, and how it made me feel like I was the only one who ever lived through the '70s.

It was like of all the eight million people in New York, no one remembered the plainness of culture before disco, or knew of the stillness and the possibility of an ethereal experience that I knew outside of New York. Everyone in New York was different from me and horses became shorthand for that.

So after being in New York for about twenty years, all of a sudden I had the urge to paint the human figure, but I put it off for a while before I tore into it, figuring they would tell me why they were there.

Think Ouija board.

I painted the figures for about six weeks until I came to a stopping place.

I put them all out, a dozen or so paintings on canvas and thirty paintings on paper.

They all looked alike.

They were all the same girl with the round face called Kay.

Kay, my first big love, the one who asked me to beat her daddy up, the one who slammed my car door when I wouldn't come in and I watched her walk up the steps and into eternity.

ANSWERING TO A HIGHER AUTHORITY

I had a productive morning painting at my studio, and then went to eat lunch at a fast-food rotisserie chicken place across the street from the Chelsea Hotel, where I lived. It tasted good and I got a refill on my Diet Coke. They were out of lids for the big-size cups so I had to be careful not to spill as I hurried to my apartment. The lobby was busy but the elevator was there, with just enough room for me and the bellhop and four guests plus cart and baggage. I squeezed in and held the giant Coke chest high. The door was almost closed when it opened again and in pushed this guy I'd seen before, who came to visit his old mother who lived upstairs.

I'd never liked this guy's looks. He was about thirty-five and his hair had a shoe-polish-brown dye job and short new bangs that were perfect and he wore a backpack so large that the elevator door won't shut. Irritated with him and his ugly brown bangs in my face I said, You have to move because the door sensors are picking up your backpack. I waved my hand out of the elevator door to demonstrate. He looked up at me with a sour expression and a bitter sarcastic reply of, If you didn't stick your hand out there, the door would close. Well, that left me with nothing to work with. Zero.

So as the door tried to shut again, I shoved my large Diet Coke in his face, and as everyone recoiled it splashed everywhere and before the ice hit the floor the sarcastic backpacker hit me once and everyone moved back and he fell into the

elevator as the door closed. That's when I hit him on the side of his face ten times before the elevator opened on the third floor and spit us all out—the guests, the bellhop, me, and the luggage cart.

Everyone except the wet backpacker. Now I was in the third-floor hallway facing the open elevator door and I pleaded, Come out and fight, as the backpacker frantically stabbed at the CLOSE DOOR button. I got back in and he huddled in the corner and said real fast, I don't want to fight. I saw that the side of his face was red.

I rode to the top floor with him and apologized.

Sometime afterward I would have to wait and ride the elevator with the backpacker's elderly mother and she would get close to me and look up and ask me how my elevator anxiety was doing.

SIDESWIPE

I was in the country coming home driving fast beside the lake in the flickering shade of the fall afternoon's low sun between the trees along the road when I saw a nice older white pickup coming the other way. And as we hit a sunny spot and passed each other I saw the driver was a young man who looked like my cousin Billy did when he was about twenty. He had those sleepy eyes. Hair pulled straight back. Kind of blondish beard.

I had thought about him recently, probably more than ever.

I had never seen anybody who looked like him. And I hadn't seen Billy in twenty years.

We met in high school the first day of our junior year. The third-period teacher was doing attendance, and she giggled and said, Andoe, Billy Andoe, and Andoe, Joe Andoe.

And we turned and looked at each other for the first time.

His grandfather and mine were first cousins. But he had grown up on the north side of town. I had heard of him. In fact, about a year before, it was in the news about how his dad had killed the next-door neighbor and then himself after their affair went bad. He did it in a parked car in front of their houses.

Billy was cool. He didn't seem affected. He said there was hardly any blood, just a little hole in the head. So Billy and his mother had moved to the east side and were living in the Gardens of Cortez apartments. He was kind of immaculate, clean; he had great taste in cars and he had a great sounding eight-track in his fast small-block '70 Chevelle that sat up just right with Cragar mags all around—fifteen-inch Gillette 60 series on the back and sixteen-inch Gillette 70s on the front. And his exhaust had hooker headers and glass packs that sounded great. It also had low 488 gears that were made for quarter-mile drag racing, and it was painted metallic blue under patches of red oxide primer and it was superclean, just like he dressed.

Think perfect mechanic who had a constant high—but not too high—from weed and Coors beer.

The only thing he inherited from his father was a closet full of guns.

And some really big ones like this old long-barrel elephant gun that he and I took out to the strip pits (strip pits were the leftover gutted land from gypsum miners that filled with water to make ponds). One winter morning we went out there and ducks were sitting on one of the ponds. We shot the sitting ducks with the elephant gun from half a city block away.

BOOM—just a tuft of feathers—that would be it.

Billy got married to a nice girl who later left him for a doctor.

He threatened her and the guy she left him for. Billy was never the same after that.

He remarried sometime later to a gal who, with him, would eventually be invited to New York to appear on the *Geraldo Rivera Show* because she claimed she was raped by the neighbors. And he didn't believe her.

Or at least he thought that if she was over there—smoking crack, while he worked—she deserved it.

That was their Fifteen Minutes.

When I got home from the country the day I drove past Billy's look-alike, I got a call from my mother who told me she'd just read in the paper that he had died.

HOMESTRETCH

There was a ten-year-old kid named Maynard who lived in an old neighborhood of small houses that never changed, set in dense foliage with a lot of crawling creatures like you'd expect in thick green. One summer day he saw a slow but deliberately moving box turtle out back crossing the open yard. He picked it up and it closed tight and stayed closed while the boy painted its shell with the paint he used for his bicycle, then sat it back out where he had found it. Soon, when the coast was clear, the turtle was on its way, but now he had a red and yellow racing stripe.

Forty years later the kid, now fifty, had just finished mowing his elderly mother's yard when he spotted a slow-moving but determined box turtle with specks of red and yellow on its back.

WALKING OUT

It seems like I just dropped him off at his very first day of school.

Remember? He was that big jolly baby with the dirty knees who was perfectly happy to still be crawling at fifteen months for the same reason he was so jolly: he knew that I had his back and that was something I never had, and neither had his mother.

Then I sat him down in the middle of the big classroom

with his new peers running a big circle around him as he sat there looking up at them.

But by the afternoon when I came to pick him up he walked right out to me.

The other day I flew down to New Orleans to pick him up from his last day of college, and I saw him walking out under the big droopy southern trees of the house where he had rented the finished attic and out to the curb so I could find him.

AND THEN I HOWLED

It was the Fourth of July and I was sitting around at my shack in the Catskills bored to tears. I needed an adventure so I splashed some gas into the tank of my motorcycle and took off, rolling up and down the pretty mountain roads around there, and when I came to a familiar fork I went right instead of left, as I normally would, because the right-hand road had a yellow diamond-shaped sign that said DEAD END.

I passed the dead end sign and expected the dirt road to end but it kept going and going, and I rode fast down the hill, under the canopy of trees, down and down the smooth dirt road farther to a stream at the end of the road where it stopped at an ancient, decrepit logging bridge that was now only a pile of stones and a few rusted I-beams high above the clear rushing stream.

I had never been here before so I got off my motorcycle and it was so nice there as I walked under the tall pine trees

and carefully made my way across what was left of the bridge, balancing myself by holding on to a tree branch (the bridge was too high not to), and when I got to the other side it was so untouched over there that I found old bottles from before there were screw-tops or bottle caps, and galvanized buckets for collecting maple sap lying undisturbed next to the bridge's old stone foundation. But then I saw a NO TRESPASSING sign and another one and another, then a house through the trees, and a truck. Then I heard someone talking, coming closer, so I went back over the stream, this time jumping from stone to stone and headed out back up the smooth dirt road faster than before. The road went on and on and I started to run out of gas and I just barely made it to the crest of the hill when my trusty bike took its last breath and I pulled in the clutch and coasted, slowly at first then picking up speed, the nearly two miles down to where I turned into my driveway, then another quarter mile curving down down down into my garage, undefeated. That was all I needed.

My whole adventure took about twenty minutes.

I know it was short.

But so is the Kentucky Derby.

ACKNOWLEDGMENTS

These people made closure possible: Jennifer Brehl and Sam Andoe.

The following pieces have appeared previously in slightly different form, as follows: "Fence" and "Eighteen-Year-Old Stucco Laborer and White Crosses," in *Open City Magazine #16*, Winter 2002–2003; "My Value," "Oppulent Treasure," "Tire Patch," "Head Case," "Principal," "Eighteen-Year-Old Stucco Laborer and White Crosses," "Spontaneous Radiance," "Cranky," "Trudge," "Wish Bone," "Top Choice," "When the Laughing Stopped," "More Songs About Buildings and Food," "King Me," "Milky Way," "On the Astral Plane," and "Answering to a Higher Authority," in *Jubilee City*, 2005 (privately printed); "Keepsake" and "Appreciation at the Door," in *Bomb Magazine* Issue #84, 2003.

About the author

About the book

Insights,
Interviews
& More . . .

Read on

A Conversation with Joe Andoe

USA Today, *in its favorable review of* Jubilee City, *refers to your "misspent youth." Is that how you regard your youth?*

I can understand why they could say that, but I think there are as many good ways things can turn out as bad. And considering how things are today, I don't think I would change anything.

And besides, I was only trying to have a good time.

During your interview with National Public Radio's Rick Karr, Karr noted this about you: "He's no horseman. He's always preferred fast cars and motorcycles." Have you ever given horses a try?

I have ridden other people's horses, and it wasn't much fun for me or the horse, but I hear tell that when it's your own horse it's a whole different thing. My horse pictures aren't equestrian; they don't have bridles. They are neighbors' horses;

> 66 My horse pictures aren't equestrian; they don't have bridles. They are neighbors' horses; they are familiar and they are always there, and they are not so much watching but considering you. 99

they are familiar and they are always there, and they are not so much watching but considering you—sort of like a chorus, a Greek chorus, or a choir—they are all similar but many and moral. They are witnesses.

You sent your friend Mike Garrett ("James" in the memoir) a copy of Jubilee City. ***What was his take on it?***

Mike started reading in prison, and so the new Mike reads a couple of books a week or more. This was someone who made me look like a good student, so when he called me and said that he'd read it in one sitting, that was surprising.

Then he said, They made you tone it down, didn't they?

I told him that the first draft was in third person and there were some things I chose to take out when we flipped it to first person. I had to dump some stories that were too incriminating, stories that I wasn't about to take responsibility for in the way I would let the "John Doe" do in third person. ▸

Meet
Joe Andoe

© Sam Andoe

BORN IN TULSA, Oklahoma, Joe Andoe is an internationally renowned artist. His short fiction has appeared in the journals *Open City*, *Bomb*, and *Bald Ego*. He is the father of two and lives in New York City. ⌒

I told him how someone suggested that I made stuff up to look good.

Mike laughed about how I left stuff out so I looked good.

Asked by the **Chicago Tribune** *to name one thing hanging on her wall, Ann Patchett, author of* Bel Canto *and* Run, *replied: "My giant Joe Andoe painting of a colt." Were you aware that Ms. Patchett owned your work?*

Not being a big reader, I didn't know who she was and I am just now learning how highly regarded she is.

Your first concert was a Byrds show back in '69. What is your memory of this?

It wasn't something we planned on; it was a last-minute deal, but I do remember how it wasn't crowded and how we upgraded ourselves to first class and how the Byrds were being introduced as has-beens by a local DJ. Even then I thought how shitty that was. And

then they came out in black leather and sunglasses and played country music through a phase shifter (a sound compressor that made it psychedelic).

I have never been the same.

How often do you get back to Oklahoma? Do you miss it? Is it still "home" to you?

I get back about one and a half times a year, but the phone is a good way to keep up my accent.

Have you ever attempted to paint a tornado?

I tried, but it sounds like a better idea than it is, because you can't make something a little phallic any easier than you can be a little pregnant.

A 1989 New York Times *review of your work—an interview concluding with the words "Like the sound of chants in a cathedral, these plain pictures reverberate in the mind"—said your paintings "consist typically of a single ▸*

66 I get back [to Oklahoma] about one and a half times a year, but the phone is a good way to keep up my accent. 99

5

flower against a mostly monochrome background. The only other decorative element is Mr. Andoe's signature." How has your signature evolved on canvas over the years? It has varied considerably, no?

Think about the "royal *we*," or how it's sort of a hillbilly thing. Even some blues singers, like John Lee Hooker, would sing about himself in the third person, and early rockers did, like Bo Diddley. Jerry Lee Lewis would sing about how Jerry Lee is going to do this and that.

My grandfather wrote his name on all his things, and when he died, I found where he wrote it on the back of his clock.

Like all kids I wrote it on my drawings, and when I came to New York, I noticed that no one was signing their paintings; then I found out that some didn't even sign the back. So I grabbed it.

There was one guy who was using his name as the subject in a painting, whereas I was just signing mine on the front and

sometimes right in the middle of the canvas.

I was trying to do as little as I could get away with by using as few ingredients as possible and mixing it with air.

I wanted to scoot up right next to nothing.

I want my writing to do the same, as in, "less is more, as long as you got the right kind of less."

Which writer's fiction, if any, would you consider the direct analogue—in terms of tone and style—to your work as a painter?

Henry Miller and Sam Shepard come to mind. Sam Shepard does American better than anyone.

And Henry Miller owned the direct feed, and was the father of all my favorite American writers who came afterward. Without him, there would be no beat poetry and no *On the Road* or *Howl*. Even Norman Mailer would not have been the same.

In your short-short story "Appreciation at the Door," ▶

> " Sam Shepard does American better than anyone. "

the protagonist, a painter named Mike (you), has a disagreeable neighbor, Richard, who claims to know "snake-style" kung fu. Richard is naked when Mike, no longer able to contain his righteous anger, attacks him. Richard, you write, "started his naked kung fu show complete with sideways walking, fancy hand movements." This makes for a highly amusing scene. Did this really happen as you describe it?

I was so sick of his threats. And I got very protective, having our baby in the house. And he held the lease, and he reminded us of that constantly. There was only Sheetrock between us and he was smoking crack, kept guns for this mafia guy from the bar, and he would throw his big bowie knife into the wall at night, over and over.

So when I came home and found out he had threatened my wife, I walked into his side of the loft, and he was standing there naked with some young woman in his bed.

And then he started his kung fu warm-up act—when he would show how he would go about fighting me—that he had demonstrated so many times before.

So then he started this Egyptian-style flat sideways walking, not looking at me, and this was supposed to scare me. (I guess maybe it would scare someone if they had never seen it before.) And then he was going to bow.

I cut his little show short because I had already seen the rest. The next day he flew home and his dad took him from the airport straight to the emergency room.

I never should have done it. I almost killed him and I broke my painting hand, and my wife didn't even say thanks.

When was the last time you jumped a turnstile?

That time at the World Trade Center is the only time I remember ever doing it. I had to.

But it's really not my style. ▶

> " I never should have done it. I almost killed him and I broke my painting hand, and my wife didn't even say thanks. "

9

A Conversation with Joe Andoe *(continued)*

Do you intend to continue writing, in addition to painting? If so, do you think you'll ever write fiction?

Like my paintings, the stories come like buses. There's always another one.

I think I have found the door to fiction, and that's where you push and pull then push some more until it starts rolling by itself and then it pulls you.

But you really only have time for one thing, so I will probably just be a painter who wrote a book. ∿

"Man Gets Hit by Bus"

In August 2007, less than a month after the publication of Jubilee City, *Joe traveled to Hawaii with his daughter. The following is an excerpt from the blog he kept during his trip.*

Waikiki Beach, Day 3:
MAN GETS HIT BY BUS
August 15, 2007:
Posted by Joe Andoe

Early this morning I was told that the *International Herald Tribune* was reprinting the review Janet Maslin wrote of my book in the *New York Times* last Thursday, and also that the *Times* is reviewing it next Sunday in the *Book Review*, and then *USA Today* is going to review it too, not to mention what has gone down already.

It's true that seven or eight years ago telling me all this would happen would have been like telling me I would become a movie actor, but even that's not as good. But then, slowly, one thing led to the next, like getting e-mail and starting to type. . . . ▶

❝ It's true that seven or eight years ago telling me all this would happen would have been like telling me I would become a movie actor, but even that's not as good. ❞

"Man Gets Hit by Bus" *(continued)*

I knew someone twelve years ago who had a heroin habit and she read submissions for a prestigious literary journal and I felt soooooooo sorry for the poor bastard whose life was in her hands because I am sure she nodded through some hard-fought passages only to miss the whole point.

Knowing that plus knowing other writers and what they go through . . . I wanted no part of that world—I had my own problems.

I am a painter and the only thing that made that easier for me was that I was better at it than anything else I could do. . . .

Not long ago I printed up some of my stories with some drawings into a comic-book sized thing and gave them out and sent them around like I would a catalog to a show.

Besides my friends liking them, that was all she wrote.

I had a box of them by the door and gave them out to whoever came around.

It was called *Jubilee City*.

Then I had this blind lunch date with a really attractive woman named Debbie Stier and after we ate she came over to see my paintings (good gig) and then I gave her one of the books to take with her.

It turned out she worked at HarperCollins and the next day or so she showed it to her publisher Lisa Gallagher who asked Debbie to call me and ask if I would write a novel.

In the time it takes to draw a breath and exhale I tried to remember the last one I read but couldn't and then thought about all the millions of books out there and that made me think how hard could it be and besides if they like what I gave them already then that was the hard part and I could figure out the rest and then I said yes. . . .

So if my success is like getting hit by a bus, then Debbie Stier has the bus schedules, and it is her job to know when they run, and then stand behind you on the curb, and push your ass out ▶

"Man Gets Hit by Bus" *(continued)*

in front of as many as she can
find until they stop swerving
to miss you and you become
a headline: LUCKY BASTARD
GETS HIT BY BUS. ᴖ

"Close As It Gets": On Writing and Painting

MY EDITOR ASKED ME to write about the similarities between writing and painting. First off, a lot of people who read *Jubilee City* asked me, Why didn't you write more about painting? You're a painter, after all.

That's a strange question to me because I felt I gave away the store when I wrote, Follow your gut, because if you have anything to say, that's when it will present itself.

I find that writing is similar to painting in that it's something you know in the way you just know, you know? I paint what I want to see and I write the story I want to tell.

It's difficult to explain the act of painting because I'm too close to it; it's kind of like my telling you how I passed the bagel shop and got this sudden urge to go in and order a sesame-bran bagel with scallion cream cheese and jelly. I can only tell you that I like the texture of the sesame-bran bagel with green onion cream cheese and sweet purple jelly and the odd way it all clashes.

To say any more would be too ▶

much information, and any deeper would make it sound too important and overcomplicate it. And besides, not knowing is more interesting sometimes.

And anyway, you never know how you are revealing yourself, *so I play it straight.*

But this I do know: Some things have a fragile alchemy, and if you lay too much on them, you crush them. It's like if you tried to pick up a cigarette ash and walk across the room with it. What interests me is building some kind of transport that gets my cigarette ash to you in one piece (so you see the art, and not the labor). This lives in the essence of what happens when you see someone yawn and then you yawn, or in a nursery when one baby cries and they all cry. How direct is that?

It works best when the paint doesn't overexplain the picture and you end up with that perfect balance of effort and content.

I like how sometimes the outcome surprises me as much as anyone. 〜

66 But this I do know: Some things have a fragile alchemy, and if you lay too much on them, you crush them. It's like if you tried to pick up a cigarette ash and walk across the room with it. 99

"Rhyme": A New Story

JAMES RAN OUT to the car and said, Let's get out of here! What did you say to her? She's really pissed off and she's calling the police.

We'd been driving around to the Tulsa bars all night in my rented red compact looking for coke but didn't find any and now it was about 5 a.m. and James was directing me to a teen video arcade.

I parked between two yellow lines and faced the muffled thumping music from behind the frosted glass windows and waited for James. I got out and sat on the hood of the car, bloated from too many beers and embarrassed that it had come to this: two forty-year-olds at a video arcade before dawn looking to teenagers for drugs.

I remember it was a pretty summer morning but I didn't care. I'm positive that the birds were singing but I didn't really notice. I just felt miserable and I wanted to go.

Suddenly the music from inside got louder and clearer. I looked up and the woman who ran the ▶

> I got out and sat on the hood of the car, bloated from too many beers and embarrassed that it had come to this: two forty-year-olds at a video arcade before dawn looking to teenagers for drugs.

17

"Rhyme": A New Story *(continued)*

place, a stocky bleached-blond woman about my age, came out and yelled to me from five cars away.

You guys are too old to be here, so why don't you just take your drugs and leave?

I was annoyed, so instead of explaining I said, Lady, if I was as ugly as you, I'd be cranky, too. ∽